DESIGN LESSONS FROM NATURE

BENJAMIN DE BRIE TAYLOR

DESIGN LESSONS FROM NATURE

WATSON-GUPTILL PUBLICATIONS, NEW YORK
PITMAN PUBLISHING, LONDON

This book is dedicated to the memory of Walter Tandy Murch,
who understood the relationship of art to nature and was
always ready to share his knowledge, and to all the young
men and women whom I was fortunate to have as students during
my eight years as a faculty member at Pratt Institute.

Copyright © 1974 by Watson-Guptill Publications

First published 1974 in the United States and Canada by Watson-Guptill Publications,
a division of Billboard Publications, Inc.,
One Astor Plaza, New York, N.Y. 10036

Published simultaneously in Great Britain by Sir Isaac Pitman & Sons Ltd.,
39 Parker Street, Kingsway, London WC2B 5PB
U.K. ISBN 0-273-0080-3X

Manufactured in U.S.A.

Library of Congress Cataloging in Publication Data
Taylor, Benjamin DeBrie, 1923-
 Design lessons from nature.
 Bibliography: p.
 1. Drawing—Instruction. 2. Nature (Aesthetics)
I. Title.
NC735.T38 741.2 73-22401
ISBN 0-8230-1323-5

First Printing, 1974
Second Printing, 1975

Contents

Acknowledgments

Many chapters in this book contain material derived from Sir D'Arcy Thompson's great work, *On Growth and Form*. The course on which it was based owes much to this man who saw no conflict between art and science or morphology and mathematics and who had a reverence for language. Wesley Lanyon's, *Biology of Birds* and E. J. H. Corner's, *The Life of Plants* are two outstanding books to which I am also particularly indebted. Other debts will be obvious from references listed in the Bibliography.

In 1966, Professor William E. Parker, who was then Chairman of the Foundation Department at Pratt Institute, first asked me to teach the course on which this book is based. Without his support and encouragement I might never have pursued the ideas contained here, nor would I be able to show the student work which forms a major part of this book. I want to thank these students for generously allowing me the free use of their work. I must also thank Professors Philip Schmidt and Joseph V. Philips, and particularly Mr. David Baum, for their generous cooperation and assistance in the gathering and organizing of this material.

Albert Christ-Janer, then Dean of the School of Art and Design at Pratt Institute, encouraged me in this project as did Chancellor Maynard K. Hine of Indiana University, who generously provided me with time while I was serving as Dean of the Herron School of Art. I thank them both.

I owe a particular debt to the American Museum of Natural History, where the work of my students, including all of the drawings and constructions reproduced in this book, was exhibited from October 1969 to October 1970. I am grateful for the major contribution of my friend Lyle Barton, and the support of Gordon Reekie in making this exhibition a success.

From the beginning, Don Holden supported this project with enthusiasm, as did Robert Beverley Hale, and particularly, Jay Gunther. My sister, Mimi Kinney, gave me valuable stylistic advice and encouragement, and my sister Alix Taylor generously helped to edit the manuscript. Norietta Gropp and Karen Byrd patiently typed most of these pages. Maureen Daugherty and Maudine Williams also provided me with valuable assistance. Diane Hines and Jennifer Place, in their editorial capacities, showed unusual tolerance and understanding. I thank them all.

Finally, I am indebted to David Blake Hobbs, then a student at the Herron School of Art, for his patience and perseverance in the preparation of all the diagrams reproduced in the text.

The following is a list of former students who contributed the drawings, designs, and constructions reproduced in this book:

Mario Abbatiello
Jane Anderson
Janet Axe
Susan Bart
Cathleen Berti
Brian Boland
Constantin Brezden
Lorraine Brod
Pauline Cabouli
Cathleen Canzani
Gail Contolini
Lawrence Craven
Bruce Elfast
Leonard Fink
John Frazee
Dana Friese
Frank Giorgini
Ernest Gross
Gail Harrison
Remi Jalbert
Robert Kemeny
Endel Koppel
Yook Louie
James Meyer
David Miller
Kimball Miskoe

Suzana Moore
David Ng
Barbara Pittorie
Timothy Pollock
Anne Pomery
Judy Preston
Frederike Rheinheimer
Ira Robbins
Timothy Secord
Ronald Selkulski
Bryan Serra
Joelle Shefts
Marc Shenfield
Keith Sheridan
Mari Solkolshi
Constance Smith
Diane Stoffel
Thomas Tai
John Triolo
Philip Vlasak
Susan Weissman
Anita Wendell
David Wheeler
Jane Winthers
Jonathan Wood
George Yalich

Diagrams by David Blake Hobbs

Preface

" Learn by heart the forms to be found in nature, so that you can use them like the notes in a musical composition."

Max Beckmann

" For me, that expressed the desire I have always had, to touch a thing, not just to look at it."

Georges Braque

This book contains the substance of talks given to a freshman class at Pratt Institute in the 1967–1968 academic year, and it contains photographs of the work done by the students in this class. I conceived the course as an attempt to establish some of the relationships between nature and art, and to propose problems which would represent a logical sequence in the development of drawing skills as well as in the understanding of design problems.

The talks in "Form and Structure," as the course was called, were delivered in a very informal way — interrupted by questions and with time taken for drawing illustrations on a blackboard. The students frequently provided the material, and their questions influenced the selection of subsequent material. This informal atmosphere, this free interaction of ideas, this atmosphere of a classroom filled with actual student work cannot be simulated easily in a written text. Nor, perhaps, can the full intent of the course be apprehended from the text alone. This was an art course, given in an art school to art and design students, yet the text may strike the reader as rather heavily weighted on the side of natural science. It may be important, therefore, to make the intent of the course very clear. It had a two-fold purpose: on the one hand, to provide the students with an understanding of the rich resources of material which nature has available for the artist's exploitation; on the other hand, to give them an opportunity for a real artistic experience. What a book cannot provide is the real, tactile experience which was an essential part of the course.

On the first day of class, after a general introduction, the students were sent out to get real leaves from real trees. These were brought to the classroom, spread out, touched, felt, examined, and then drawn. The analytical observations, the scientific information with which they were then provided had only one purpose: to interest them, to excite them, to awaken them into making a meaningful drawing of a leaf. For this reason, whenever the problem permitted, the students touched, felt, and handled the subjects which they were to draw. They boiled bones. They dissected seed-pods. They broke eggs. They made prints from real fish and, when direct action was not possible, they went to the Museum of Natural History and looked at skeletons. They met at the fish market, they flew kites. It was the reality of these experiences, the direct, tactile involvement with actual materials that, in my view, produced the beautiful drawings and constructions reproduced here. The talks, the essential text of this book, had for their primary aim to arouse the students' interest in the subject, to make them want to handle it, to give them a feeling of mastery over it, and to sharpen their faculties of observation. If much of this material seems more devoted to arousing a student's interest than to training him as an artist, it may simply reflect my conviction that this is half the battle. The other half of the battle is the experience of handling real things, which the reader is invited to undertake for himself.

Chicago, Illinois
1973

Introduction

" 'My hands,' said the Centaur, 'have felt rocks, waters, plants without number, and the subtlest impressions of atmosphere, for I lift up my hands on dark, still nights to detect the breezes and so discover signs to make sure of my way.' ".

Henri Focillon

In this book we are concerned with forms in nature, with drawing, with ways of thinking about art and about design. These are related. Have you thought about nature, about your relationship, as artists, to its processes? Have you thought about your bodies, about life, as closely connected to your need to create and to construct? Have you considered the fact that everything that nature produces has form — not just leaves, fruit, birds, and elephants — but clouds, drops of water, oil, and air?

When an artist plans to build something, he gathers materials together, piles up clay or bits of wood, collects tools, and clears a space for work. This is how the world began — gathering materials, clearing spaces, piling up reserves by volcanic eruption, earthquakes, floods. From this, slowly and with effort, in more than seven days, the world grew. So does a sculpture, a construction, a building.

When an artist begins to run a pencil aimlessly over paper, creating smears and smudges, it is like wind running over sand, bending grass, rippling water. It is like the beginning of things, but it can also be something valid to express. It, too, can leave form. When an artist begins to work over his smudges, to define edges, to emphasize outlines, to fill in details, he is proceeding as nature does.

We can see a profile suggested in a cliff, animals taking shape in the clouds, sea life forming in the folds of a wave, and in our own penciled smudgings we can recognize a face, the outline of a hand, or the emergence of a form with the same astonished recognition. Art is miraculous, but it is only a small echo of the great miracle of growth, of the constant process of creation and re-creation which is the way of nature.

What is remarkable about the forms of nature is their capacity for self-reproduction, for self-perpetuation, for both change and continuity. As scientists, we would be concerned with the essence of such changes, with the essential nature of processes, but as artists we can see this in the forms themselves.

A bone is the beginning of an understanding of the vertebrate skeleton, of the lives of animals and men, of the evolutionary history which produced our world. It is also the solid and necessary basis for an artist's drawing of form.

The extraordinary quality of those drawings of the human figure created in the Renaissance is due, in large part, to their emphasis on the structural and mechanical aspects of the body. The figures of Luca Signorelli, with their heavy clavicles and deep-set necks resembling turtles, and their enormous, rounded shoulder blades in the shape of miller's wheels, convince us by their emphasis on

10

essential structural and functional truths. The sense one gets from the drawings of Michelangelo and Raphael — of the musculature beneath the flesh, of the hard, bony underpinnings — is a reflection of the excitement of discovery which Renaissance artists felt about the body and its functions. It may not be possible to recapture this sense of structure and function in relation to the human body, but it is still possible to understand its importance in relation to art.

The glass cases in the American Museum of Natural History which display the skeletons of horses in various running positions are among the most exciting and beautiful visual forms to be seen in any art museum. Nor can I think of many artist's creations since the great age of Greek sculpture which can rival, in sheer visual drama, the glass case containing the skeleton of a rearing horse and that of a man with arms raised, as if reaching for the bridle.

The forms of nature have a quality which only rarely marks a work of art: the feeling that something must be as it is, that it cannot be otherwise. Art does not have an obvious function and, if it is to avoid becoming mere decoration, it must convey its own sense of necessity and of inevitability. At the same time, a great work of art must be full of analogies — a shape that makes you aware of many shapes and therefore becomes a measure of all shape; a color that makes you aware of "color" and therefore of all other colors.

To an artist, a bad drawing is the depiction of a form which can only be identified by the mind — an outline that serves to indicate a shape but does not convince. To convince the viewer that he is seeing something, a drawing must contain impressions of the artist's conviction, his involvement. An object is not its outside shape, nor the shadows and highlights which reveal its forms, but its presence from inside. In art, the presence from inside must be expressed through the artist's materials. A bone, truly rebuilt of charcoal, absolutely constructed from charcoal, becomes a reality on paper. The artist's concentration on the charcoal, on that paper, and on his own belief that a real bone is coming to life through this material — more real, perhaps, than the real bone — is what makes his drawing come to life.

Artists can learn from nature about lines and shapes; about scale, color, and texture; about the meaning of form and the significance of structure — about all the processes which he is ever likely to encounter in his life and work. And, if he can get close to his materials, touch them, feel them, love them, and understand them, he will have properly begun his training as an artist.

1 Leaves

"I look at those leaves with their architecture of veins, their stripes and mottlings, I peer into the depths of interlacing greenery, and something in me is reminded of those living patterns, so characteristic of the visionary world, of those endless births and proliferations of geometrical forms that turn into objects, of things that are forever being transmuted into other things."

Aldous Huxley

Although I will begin this book by talking about leaves, and I will ask you to draw them, we are not concerned with superficial description, nor are we concerned with science as such. We are instead pursuing a knowledge of drawing and searching for forms and relationships which, both in nature and in art, express function and therefore meaning. To do this we will need to be somewhat scientific. But this means that we will need to be nothing much more than observant, intelligent, and patient — a good definition for any artist!

When we speak of leaves we generally refer to those produced by deciduous trees of the angiosperm category — oak, maple, birch, linden, chestnut — and in fact to the large majority of modern plants. The gymnosperms, dating from an earlier era, also have leaves, but, except for the ginkgo, they are primarily of the needle-like variety produced by pine, spruce, hemlock, cedar, and fir, which do not shed in winter. Cactus needles are also leaves, but they have yielded their functions to trunks and branches, and serve only as guardians of the stored water and sugars.

Gymnosperm means "naked seed" in Greek, and trees of this type have been so named because they do not produce flowers, and their seeds are not covered by a fruit. Angiosperms, or "covered seeds," dating late in the evolution of plants, produce flowers and fruit and a wide variety of broad-leaf shapes — toothed like a buzz-saw in elms and pussywillows, lobed in maples and oaks, or divided like fingers into leaflets in the buckeye. Broad-leaf construction exposes a wide surface area to the light. This area is supported by a complex system of veins that also carries water and food. Inside is the chlorophyll where water, carbon dioxide, and sunlight are turned into sugars. The outside of the leaf is waxy, to prevent the evaporation of water, and the underside is matte and spongy to absorb carbon dioxide and exhale moisture.

The color of a leaf is green in summer due to chlorophyll and is yellow in the fall due to carotene. All plants contain carotene, in fact the yolk of an egg is yellow because a chicken eats grain. Some leaves turn red in the fall because an excess of sugar is trapped within them as they begin to die.

Is the character of a leaf in its color, in its shape, or in its veins? Which of these elements provides the most vivid evidence of the purpose of its existence?

I hope you will agree that the delicate system of veins, which carries water and oxygen and sugars and holds the leaf outstretched towards the sun, most dramatically expresses a natural function. It is a basic design, shaped like a tree, like a river

12

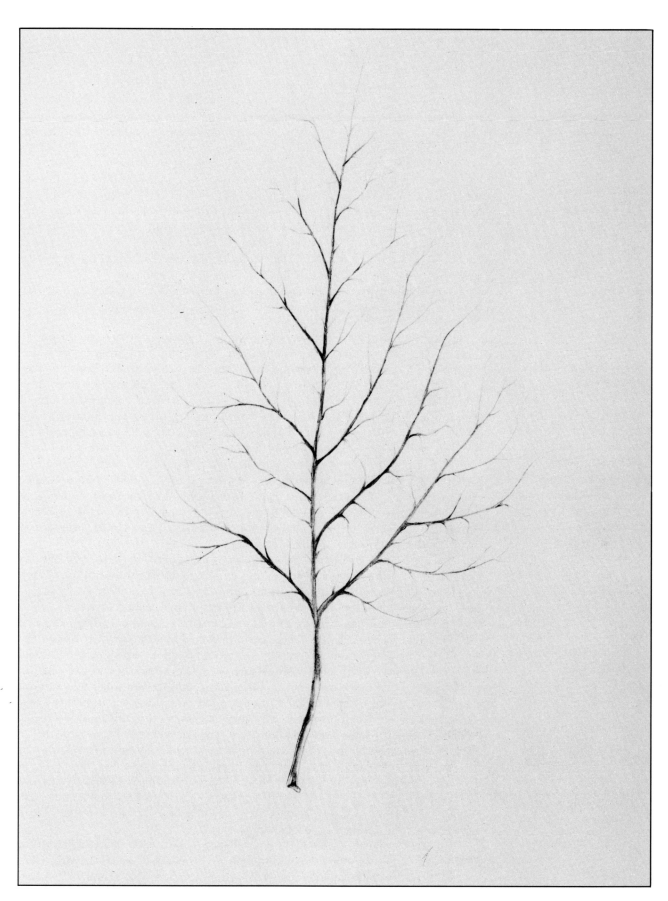

Vein Study, *pencil on paper. Only the most visible veins have been traced in this careful and exact study of a leaf.*

delta, like lightning. It is bold and subtle, complex and simple, intricate as a maze and obvious as a page of squares. It is one of nature's most beautiful designs, and it is all for a purpose.

If you carefully study an actual leaf, you will notice three particular aspects of the system of veins. First, the veins cover most of the leaf surface, subdividing it into approximately equal segments. Second, the veins vary in thickness. Third, they branch off at different angles. These subdivisions, variations of width, and changes of angle are the essential design elements in the veining system of a leaf. It is on these characteristics that an expressive drawing must focus.

Nature is never extravagant — minimum waste and maximum efficiency are the general rules. Before considering the problems of relative thickness and the angles of branching, consider for a moment the overall problem of the design in a network of veins. Nature has produced two possible solutions to the problem of distributing a liquid equally over a given surface (although one design is most common). It would be worth your while to ponder the probable reason for the design of veins and the two possible solutions to the problem.

You should bear in mind that water distribution is the primary function, that water enters the system at one end only, and it must be brought to every part of the leaf and must not be wasted.

It may help if you visualize an oblong shape about the size of a room. Consider then an irrigation system of pipes of various sizes which will bring in the water from one point and reach to every part of the room. You should consider that pipes are expensive, and larger pipes more expensive than smaller ones. You should also consider that, although a large pipe can carry more water than a small one, it is more wasteful; more energy is required to pump it and more of it can evaporate. On the other hand, a small pipe carries less water, develops more friction, and will not span as great a distance as a large one.

You might agree that the most appealing solution is to bring at least one rather large pipe from the point of entry to the furthest point — maximum water for the maximum distance. From this, smaller pipes, placed at right angles, or at some other angle, could be run out to the sides at approximately equal distances. From these, if necessary, even smaller pipes could run. A number of variations of this basic design are also possible.

A second approach could be to run several medium-sized pipes from the point of entry to the furthest point, bending them to fit the contour of the oblong and spacing them approximately equal distances apart. I think it would be difficult to think of solutions that would not be more than variants of these two quite basic arrangements, so long as the shape remained oblong. Indeed, the two solutions described represent nature's two principal methods of distributing the veins in a leaf. The first solution applies to all dicotyledons, and the second to all monocotyledons. The monocotyledons include grain plants, lilies, grasses, palms, and all plants that grow from bulbs. They are a more recent form of evolution than the dicotyledons, which constitute the largest category of plants in the world. These include all deciduous trees, all plants not monocots, and most weeds.

There is a third possible solution which applies at this time to just one tree, a leftover from an earlier stage of evolution — a deciduous gymnosperm known as a ginkgo tree. It presumably survived in China and was imported to the West long ago. It has a fan-shaped leaf, and the veins run in the shape of a fan directly from the stem to a dozen points on the broadened tip. The ginkgo, incidentally, can function effectively on less carbon dioxide than almost any other tree and today it is often the lone survivor on many city streets.

Now that we have examined the overall design of the veins, I would like you to look at the angles at which branchings occur. You will observe that the veins spreading out from the main trunk tend to form an angle of less than 90°. In fact, in many cases, this angle will be set at 45°. In very thin leaves it may be as little as

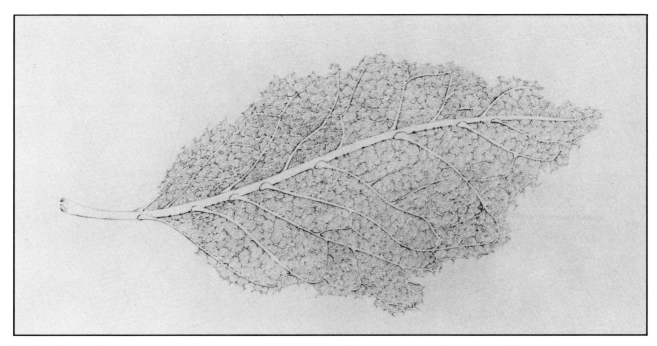

Leaf Study, *pencil on paper. The artist has exaggerated and stylized his observations, but they are basically accurate.*

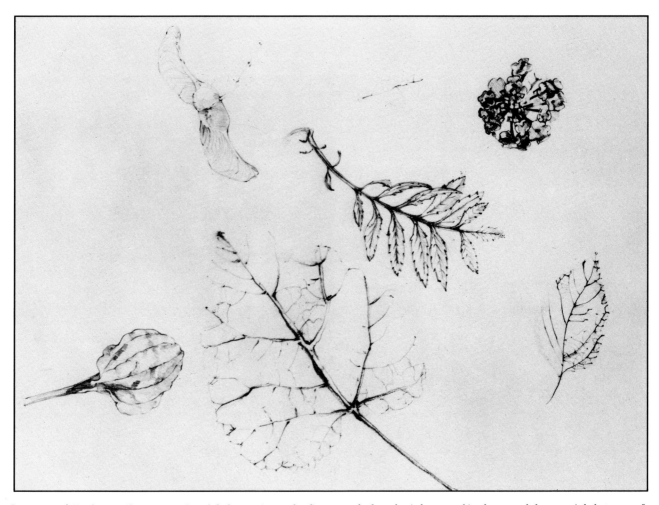

Leaves and Fruit, *pencil on paper. Careful observation and a fine control of emphasis have combined to reveal the essential character of natural forms.*

30°. In broad leaves, it may be 60°. This angle has to do with the relative thickness of these first branchings in comparison with the main trunk. The general rule is, the thicker the vein the smaller the angle, or the thinner the vein the larger the angle, so that the angle will almost always be between 30° and 60°. If you observe the very smallest veins, you will see that the rule is applicable there and that nearly all of the very thin veins branch off at 90°. The angle is always a function of the thickness, and this rule, which has its basis in engineering and thermodynamics, provides both the variations and the consistencies of the overall design.

The Problem Draw the system of veins in a leaf, with precision and exactness. You may use either ink or pencil. Draw what you see in the leaf before you, paying no attention to the outside edges until the end. In fact, if the veins are rendered exactly, the edge will be implied and may not need to be drawn. Be careful to use whatever instrument you have selected in such a way as to indicate the thick, thinner, and thinnest gradations of veins as closely as possible.

The Drawing The least satisfactory and yet most direct, most preferred, and unfortunately most primitive form of drawing is the outline. The obvious outer shape of objects holds an irresistible attraction for artists and ignorants alike, as if the detail, color, texture, relief, or design of objects had either no significance or were always subordinate to the outer form. Obviously, this is not so.

If you draw the outer shape of a leaf, you will have the insignia of the Canadian Mounted Police, the emblem of the state of Vermont, a plastic table mat, a ladies compact, or a silver brooch, but you will have no more than a generalized symbol. The veining system of a leaf is a form with a specific function, not a symbol, and it can make for a very particular and a very interesting drawing.

In drawing the veining system you will have to be very precise, observant, painstaking, and slow. This is the way you should approach drawing throughout this book; it will help you to see clearly, and to learn to render exactly.

There are variations in the thickness of the veins, and these must be rendered as they are. You may choose, if you are using a very fine-pointed instrument, to draw the veins by their outlines, that is, to draw a line representing each of the two sides of the canal. Or you may choose to use a thicker line and to represent each vein in one stroke, varying the intensity according to the thickness. If you use two lines to represent the two sides of the veins, keep in mind the possibility of making one side darker or stronger than the other to emphasize its three-dimensionality. A change in emphasis will do this very effectively. In any case, it is important to define the various gradations of the veins and to include the very smallest ones. You will have to look closely — perhaps with a magnifying glass — to note the smallest lines and the angles at which they branch off from each other. Design and engineering principles are both at work here. I have seen many stylized drawings of leaves with the veins sweeping about in great decorative swirls, enough to make any self-respecting artist blush with shame and nature shudder. Do not be guilty of carelessness in observation!

There is much to learn from this kind of drawing. You will learn to be precise about thickness and thinness, about changes in direction, about estimating angles, and about approximating length. These are all very important in any kind of drawing based on observation. There is also a lesson in leaves about the distribution of lines in space. You will notice, if you concentrate for a moment on the unlined parts of the leaf alone, that all the subdivisions are of approximately equal size. If, as an artist, you needed to break up a given space into a number of equal subdivisions, you might be tempted to resort to the methods of the surveyor or the realtor and impose the visual grid of North-South, East-West lines on your space. In the veining system of a leaf, you have another suggestion. One or more main directions are defined with bold lines. Less emphatic lines, extending out at

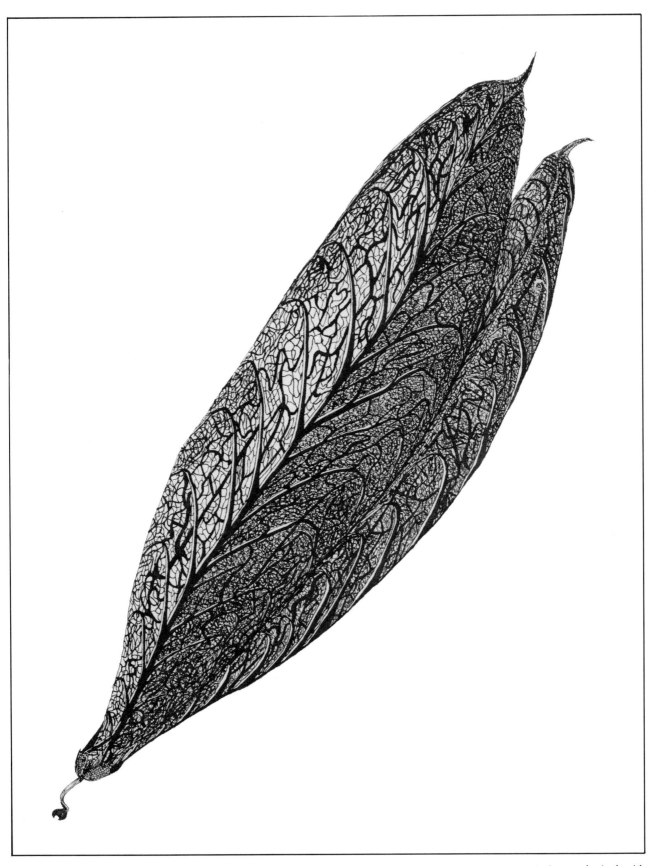

Two Leaf Studies, *ink on paper. The artist has taken liberties in stylizing the vein formations of the leaves, but he has emphasized, with strong visual impact, the importance of the vein in the structure of a leaf.*

angles, branch from these. Finally, very subtle lines change direction again and complete the grid at a different angle. Equal subdivisions can be achieved without regularity by this method. A drawing acquires directions, sub-directions, subtleties of emphasis impossible with a straightforward grid.

It is worth taking time to study a variety of leaves in order to appreciate the different relationships that are possible between the veining system and the outer form. The same system can adapt itself to a great variety of shapes.

One final word of caution. The greatest enemy of this problem is haste. You must be prepared to go slowly, to take pains, to proceed one step at a time. If, in the process, you should become hypnotized by the maze before you, you will not only have been transported to that world where "things are forever being transmuted into other things," but most likely you will have produced a beautiful drawing.

The Angles and Thickness of Veins

As I mentioned earlier, the veins of a leaf vary in thickness according to their function and direction. The main trunk, bringing water from its source at the stem, will be the largest vein and will proceed, although with diminishing girth, straight to the farthest point of the leaf. This conforms to the principle of thermodynamics: the larger the pipe the more efficient the distribution of a liquid over an extended distance. There is less friction from the surface walls of a large vessel than a small one, and less loss through evaporation, seepage, and other causes. For short distances, however, when only a small quantity of liquid is actually needed, a large vessel carrying more liquid than is necessary is wasteful. In this case it is more economical to have a small vessel that carries only the precise amount of liquid needed. That is why the sizes of the veins in a leaf diminish as the distance between points grows shorter. The degree of efficiency of a tubular system depends on the ratio of its length to its diameter.

Water is precious to a plant, as precious as blood is to a human body. If blood were an easier substance for the body to manufacture, our veins would be larger and our systems would function more economically. If the diameter of our blood vessels were doubled, the blood volume carried would be quadrupled. The work-load on the heart would be reduced to one-sixteenth of what it is now. On the other hand, if blood were costlier to manufacture, then the body would need narrower blood vessels to hold the supply, as well as a much larger and stronger heart. The same principle applies to water in the plants. In fact, human blood vessels are laid out precisely according to the principles which determine the arrangement of veins in a leaf.

In addition to thickness, the angle at which veins branch off from each other affects the economy of the system.

As we have seen, the smallest veins in a leaf tend to branch off from each other, and from the next larger ones, at an angle of approximately 90° (or at right angles). As we look to the next larger veins and on to the largest, we notice that the angle of branching becomes progressively smaller, from 60° to 45° and sometimes to 30°. This general principle applies not only to the leaf but to the arrangement of blood vessels in the human body, to the branching system of trees, and to all the other veining systems of this sort.

To understand the reason for the varying angles of leaf branching, we should examine a simple diagram representing pipes of differing thickness through which a liquid is flowing, and a point, X, which the liquid must reach (Figure 1).

A liquid flowing in a vessel, A, in the direction from D to C, and having to reach point X, has two general choices. It can follow the direct path represented by the line C-X, or it can make a 45° angle, remaining in the direction of flow, and following the line D-X. We can see that, by continuing up the line D-C, and only then branching off to X via the line C-X, the liquid is carried to its farthest

possible point by the most economical means, and the smallest distance by the least economical means. However, the abrupt change of angle, and the change from a large to a small diameter would not assure adequate maintenance of the required pressure. In this case, the line D-X represents a less sudden change in diameter and branches in a direction that preserves the maximum pressure borrowed from the central vessel. We can see that 45° is the angle which provides the maximum movement away from the central stem while also retaining the maximum thrust from the main source of flow.

We can now go back to our leaf-veining system and understand, for example, that the secondary system of veins can branch out from the main stem at 45° not only because the angle is more direct and the pressure required for easy flowing is at its minimum, but because it can also be assumed that the diameter of a secondary stem remains large enough to allow for relatively economical passage. It is not until the stems assume a still smaller diameter that a degree of inefficiency enters the system, causing it to measure every distance and every angle with care. It is then that we observe branchings of 90°.

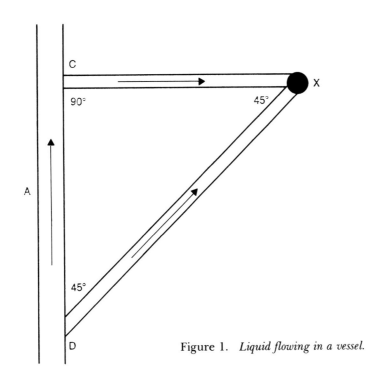

Figure 1. *Liquid flowing in a vessel.*

2 Fish Skeletons

*"The observation of nature
is part of an artist's life."*
Henry Moore

The skeleton of a fish constitutes what is known as an "articulated system," or an arrangement containing branchings connected to a main stem by a series of joints. A system like this would also fit the characteristics of a leaf. As a drawing problem, both involve the placement of lines at various angles in relation to a central axis, changes of thickness, and subdivision of spaces. They both result in a complex grid that forms a structure and defines a function.

Leaves and fish are only superficially worlds apart. Like a sophisticated naturalist, an artist becomes accustomed to the transcending of time in pursuing analogies of form. Through the millennia of evolution, nature has not changed her methods nor altered her basic purposes. Plants and animals began together in the sea a million years ago, and they remain analogous, related, and interdependent. The classic elements of earth, air, fire, and water created all their forms. Now, as in the beginning, all of nature's structures demand water, resist pressure and gravity, seek light and warmth, and require oxygen. The bones of fish and the veins of leaves are not casually related; they are profoundly bound by a mutual dependence on the four elements.

Fish are the ancestors of animals and men, and their bone structure is the preliminary form of our own. They evolved in this direction slowly from amoebae to wriggling creatures. As the land masses rose and receded and the oceans became shallow and deep again, sea creatures developed bony armor-plates with which to resist pressure, and they used primitive tubes to suck nourishment from the ocean bottom. As they slowly evolved a movable jaw, they sought other food and, eventually, greater freedom of movement. The armor-plate subdivided. A spine developed to connect the parts. Bone projections and flexible ribbing replaced the outer shell. The extended spine withdrew from the tail, leaving a flexible cartilage connection. As steering and propelling became possible and urgent, paired and balanced fins developed to enable both braking and turning.

Along with bones and vertebrae and movable jaws, fish pioneered the functions of paired eyes and ears, of hearts and kidneys and livers, of veins and blood, of lungs and breathing systems, of nerve tissue, and of centralized nervous systems and brains. In fact, it required only a few minor changes for a fish to crawl from the water to become, initially, a reptile, and eventually, a walking, talking mammal like ourselves. The mud-skipper and lungfish can walk long distances on pectoral fins and breathe directly from the air, and something

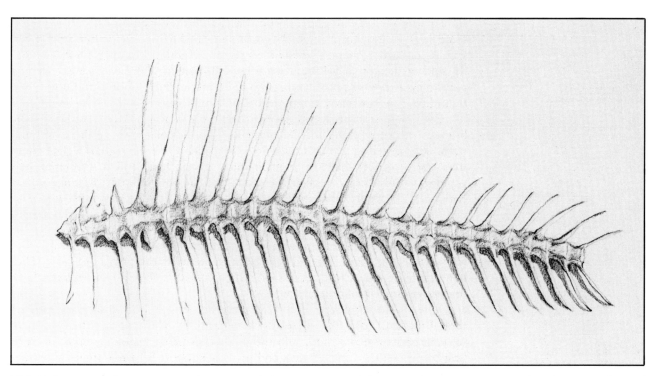

Fish Skeleton, *pencil on paper. This direct yet subtle drawing of a fish skeleton reveals how the impression of regularity is made up of variations in thickness, direction, and spacing in each tine.*

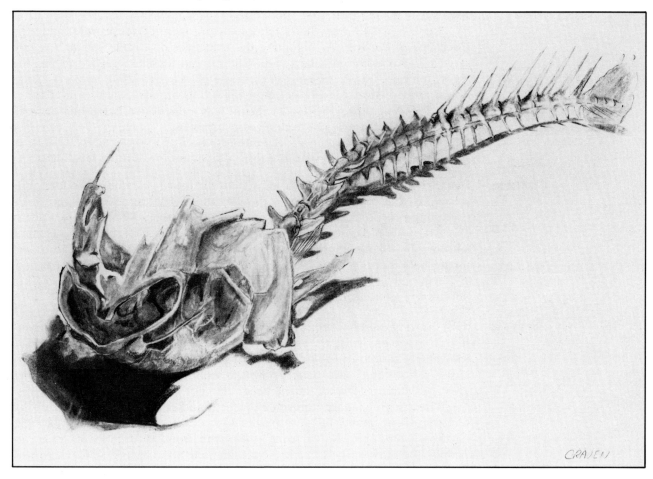

Fish Skeleton with Head, *pencil on paper. With the help of dramatic shading, the variations of angle and spacing are all made clear.*

similar was our fish ancestor. Pectoral fins are in the right position for forelegs. Hind legs developed on land. I recommend that you look at the skeleton of a seal, if you have a chance. You will see there, tucked in just in front of the tail, at the end of the spinal column, two very well-formed feet, but no legs. An adult may be disturbed by recollections of Thalidomide, but a child would understand that nature makes many things and almost anything possible.

Although creatures and species become extinct, nature's studio remains littered with early experiments. Amoebae and tadpoles and crustaceans remain in the sea, as well as fish that have no bones, such as rays and sharks. They never took the direction that led to movement on the land and to the creation of reptiles. Chordates, with their skeletons, did, and their bones, spinal columns, and most of their other organs are those we share today with birds and elephants, mice and frogs, cats and dogs.

Today, the vast majority of the 20,000 species of fish have bony skeletons that support their movement in the changing temperatures and pressures of the sea, and permit them fast and precise movements in the pursuit of prey. These bony skeletons have few variations and constitute a structure very basic to the understanding of all animal form.

The spinal vertebrae of fish vary in size, length, and design according to their function. Fish, like ourselves, have sections of the spine which form the neck, support the ribs, and hold the tail. Tines project directly from the vertebrae to protect the inner organs and provide support for the muscles. The flexibility of the vertebrae enables the fish, by the flexion of muscles against the tines, to move sideways and to propel itself through water. The fins, which mostly serve as stabilizers and steering mechanisms, are not attached to the spine and are usually made of cartilage, not bone.

Much as in the human body, tendons acting against tines provide rigidity for the frame of the fish. Acting along the principles of a cable bridge, the tines serve as compression members. The tendons and muscles attached to the tines act in the manner of tension cables, those on top providing support against downward pressures, and those below providing support against upward pressures. This system provides forces against which the side muscles can operate to force the flow of water and to develop propulsion.

The fish's skeleton permits the interaction of all its other parts; it is the essential element which suggests the fish's shape and explains its flexibility.

The Problem Buy a whole fish and boil it yourself, so you will have some understanding of the relation of the bone structure to the overall external appearance and to the swimming function of the fish. Then draw the skeleton. You may use a pen or pencil. You should observe and record every visible detail of the spinal vertebrae and the ribs, the spacings between them, their angles, thickness, curvature, and the formation of the joints. The drawing should be well-placed on the page and all the essential elements should be included, although the head is not necessary nor are the tail and fin extension.

The Drawing This drawing does not require the use of shading. A fine-line rendering should permit you to record all the essential elements of the bones. As in the drawing of the veining system of leaves, varying the intensity or darkness of the lines on either side of the same bone projection will emphasize roundness and help create an illusion of space on the page.

The fish skeleton exhibits more perfectly and clearly than the veins of a leaf a characteristic quality of the repeated forms of nature which might be called rhythm. There exist, for example, millions of trout, shrimp, leaves, dogs, and people, and most of them can be described quite accurately in similar terms, yet seldom are any two people, two trout, two shrimp, two leaves, or two dogs exactly alike. They are repetitions, but never mechanical ones, never exact duplicates,

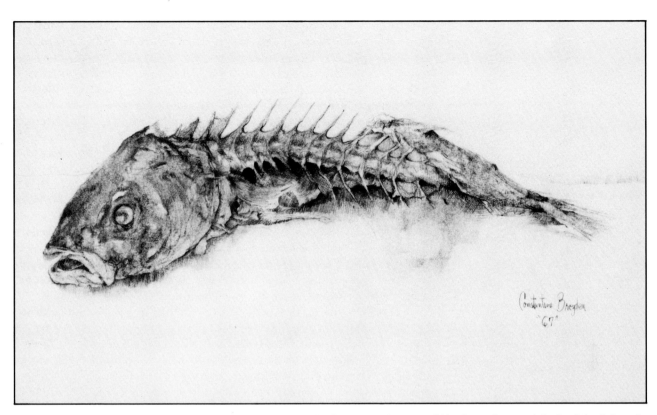

Fish Head and Skeleton, *pencil on paper. This drawing of a dead fish is, in fact, incredibly alive. The essential role of the skeleton in establishing the form of a fish is clearly revealed.*

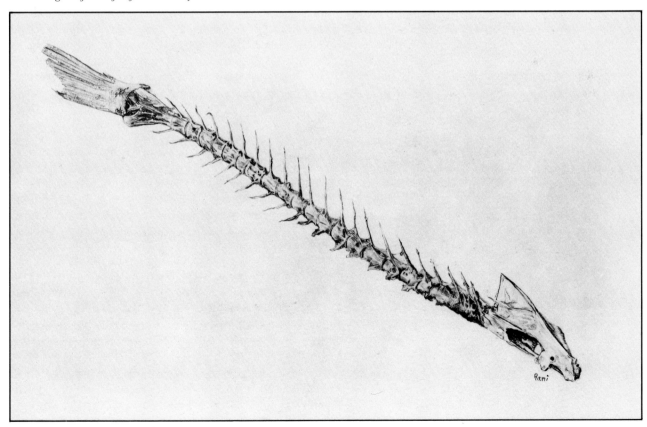

Fish Skeleton with Head and Tail, *pencil on paper. The beautifully detailed vertebrae in this drawing reveal the role they play in altering the angle of the tines.*

never precise reproductions. This capacity for repetition with infinite variation is one of the marvels of nature. When this is observed at close range — when a shell is marked with regular serrations, when a sea urchin is covered with a hundred spiny projections, when a skeleton has a dozen parallel bones — we become aware of a variant quality in spacing, in size, in projection. It is this quality that gives this grouping a rhythm. Mechanical precision can make us aware of a single-minded function, of an obvious purpose. We generalize without feeling the need for detailed observation. The teeth of a comb, of a rake, of a bulldozer have no individual interest. We perceive at once their mechanical perfection. In nature, however, everything raises questions of beginnings, ends, and processes. One tooth is long, another short, and immediately we think of analogies of younger and older, underdeveloped and overdeveloped. Angles of directions vary, and we immediately question which is the major direction and which the secondary. Priorities and hierarchies are established which suggest growth, change, movement, or purpose. The repetitions of nature are not precise. They create rhythms, variations on a theme, a balanced order of inequalities. This can be observed in the placement of bones in the skeleton of a fish, and this is the quality that your drawing should have.

Drawing from nature with exactness can train the eye and hand for the kind of loving attention to detail that great art requires. An artist, working entirely from memory or imagination, runs the danger of repeating himself, or of being reduced by an effective gesture that might convey his intention once, but not twice. Machine-made things are precise, repetitious, and dull. Mechanical perfection is a seductive and dangerous ideal in our society. It is also easy. It fits the pattern of our training and the habits of the mind when it operates without emotion. Nature never does this.

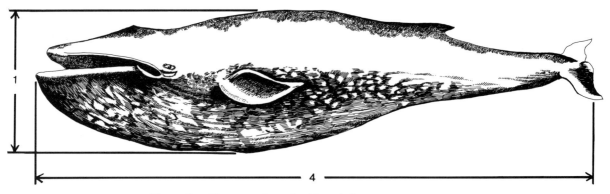

Figure 2. *The proportions of a blue whale.*

You will notice that it is rare for any bones in the fish skeleton to be the same length or thickness, or to be angled in the same direction. Together they will suggest the form of the fish in outline, yet they seem each to have been created separately. One is more pointed, one is wider, one is notched slightly. They were executed each in turn and cast from an idea, not a mold. Similarly, the spaces between bones are not equal, and an artist can learn to observe shapes as much from the negative effect as from the positive effect. And the negative effect can more frequently help him to recognize the quality of rhythm. The space between bones is large here and narrow there, more open at the top than at the bottom, or vice versa. Here the shape is square, there rounded.

So-called "primitive artists" are, I have always felt, people who have developed a special mania for the way nature creates details. They seem to fall in love with the idea of imitating nature by proliferating detail with infinite vari-

ation and care. Their embroidery has no two stitches quite alike. This is no small accomplishment and it is not false to art. However, it is not all.

Most artists have, in my opinion, rather strongly schizophrenic tendencies, in which a love of precision and detail is mixed with an equal love for big gestures, grand generalizations, and all-encompassing ideas. This is a good mixture if bold imagination is used to separate the important from the unimportant, and if the capacity for detail is used for the execution of each line and tone. May it be so with you.

The drawing of a fish skeleton can be a bold and beautiful thing. It can contain all those precise and varied details that turn the works of nature into objects of wonder.

The Buoyancy and Movement of Fishes

The skeleton of a fish is often a delicate and lightweight structure; its weight in water is practically negligible. However, most bottom-dwelling fish must move constantly to avoid sinking. Their weight remains subject to gravity, and their buoyancy under heavy pressure is in a precarious state of balance. Higher-dwelling fish have a gas bladder, something like an air sack or balloon, which adjusts chemically to different depths. Responding automatically to changes in density, the bladder keeps the fish afloat. However, the fish cannot go below a certain depth. If deep-dwelling fish had gas bladders, they would be subject to such tremendous expansion as they tried to rise to the surface that the fish would be in danger of blowing up.

Since water is incompressible, the shape of fish and water-dwelling mammals such as dolphins and whales has a tremendous influence on their ability to move with any rapidity through this medium. A certain width helps in sitting still. A pointed front and rear allows for pushing its way forward. It is interesting

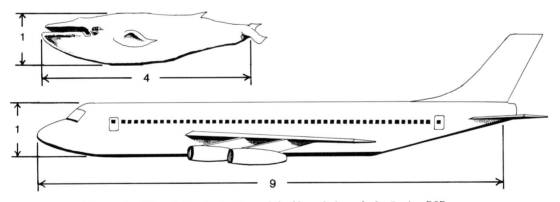

Figure 3. *The relative proportions of the blue whale and of a Boeing 707.*

that very thin fish, like the flounder, move on their sides. The ray is flattened from the top and moves in a horizontal direction. In comparison with modern airplanes, fast-swimming fish are very wide of beam. The tuna, dolphin, swordfish, and blue whale, which are among the fastest of all swimmers, share similar body proportions, with an average length that is only four times the diameter of their middle width (Figure 2). While they are sharply pointed at the nose and tail, it is interesting to know that these rather wide structures represent the maximum volume, allowing for minimum drag in water. It has been calculated that the effects of drag and turbulence on airplanes would be greatly reduced if their fuselages were thicker, and their general proportions approached the one-to-four ratio of the blue whale. The greater mass, however, would require a sharp increase in the power needed for lift-off. The Boeing 707 has a ratio of one to nine (Figure 3). The more recent 747, considered the most stable airplane

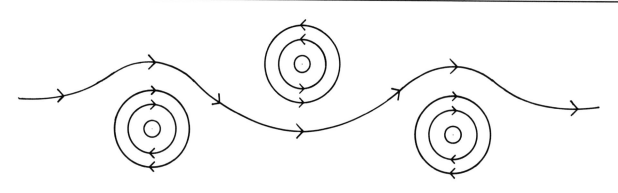

Figure 4. *Water movements created by the tail and fin motions of a speckled trout.*

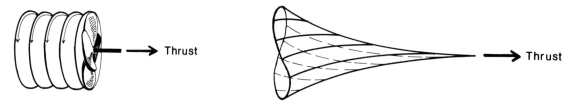

Thrust

Thrust

Figure 5. *Thrust generated by the motion of a propeller and by the tail movements of a sturgeon.*

Figure 6. *Movements of the tail of a trout starting from a position of rest (1). Maximum thrust is generated between positions 2 and 4.*

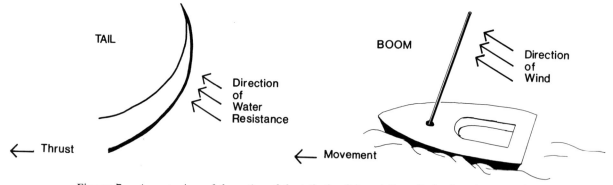

TAIL

Direction
of
Water
Resistance

Thrust

BOOM

Direction
of
Wind

Movement

Figure 7. *A comparison of the action of the tail of a fish and the sail of a boat in generating propulsion.*

ever made, has a ratio closer to one to six and is highly resistant to turbulence.

In the case of fish, the drag on rapid movement is greatest at the water surface, where wave motions are created. This helps explain the leaping habits of the dolphin which, like whales, must breathe in air. By breaking the surface at a sharp angle, they are able to avoid surface resistance and maintain their full forward momentum while breathing out of the water.

A fish moves in water by sideways motions of the tail and fin. In doing this the tail creates circular currents, or eddies, which assist propulsion. In addition, circular oscillations of the tail and rear portion of the body, most developed in the faster fishes, such as sturgeon and dolphin, create a generalized forward thrust that operates on the same principle as a propeller (Figure 5).

In starting from a standstill position, the initial thrust of a fast-swimming fish is provided by a rapid contortion of the whole body and the tail, generating maximum pressure against the incompressible resistance of water. The trout can change position completely in 1/20th of a second. In this time the thrust generated is such that in .15 seconds a trout can reach a speed of four times its length per second.

In generating propulsion against the resistance of water, the tail fin acts something like the sail of a ship, gaining thrust by pressing against water at the most favorable angle.

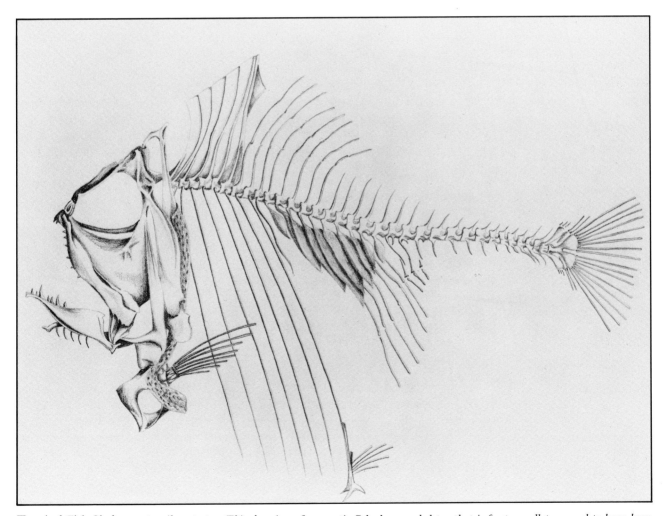

Tropical Fish Skeleton, *pencil on paper. This drawing of an exotic fish shows a skeleton that is far too well preserved to have been drawn, as is, from life. However, it does suggest the outline of an interesting shape and the many varied, small units which constitute its structure.*

3 Trees

"Trees are substantial organic structures and they frequently last for many years more than do men or birds or fish or the contrived dwellings or nests of men."
Buckminster Fuller

The life cycle and formation of the tree is entirely dependent on the four elements: earth, air, fire, and water. Little that lives can do without them, and that is perhaps why art schools in France have always demanded that students represent, allegorically or abstractly, this favorite theme of antiquity. All the elements can be represented in themselves, in specific forms, but every form in nature also reflects them, is formed by them, created in response to them.

The tree stretches its branches to the sun, the leaves turn to expose themselves to it, they breathe out air and breathe in gasses. The roots imbed themselves in earth and draw great quantities of water through the trunks and branches, and the leaves evaporate it to the air.

As animals possess a tail, a head, and a body, trees consist of three different parts: the leaves, the trunk, and the roots. Like the animal skeleton, the tree has a main trunk with joints and branchings, and it is an articulated system, although it is not mobile.

Like mammals, descended from fish that came up out of water, trees are the descendants of those plants that crawled out of the sea. Ferns are considered the first of the truly land plants, and they are the ancestors of trees. Like ferns, the first plants grew directly from a root center. The trunks and divided branches of trees and bushes came much later. In the tropics, many ancient forms of plants grow to the height of and have the appearance of trees, without being trees. The bamboo, which can grow to 180 feet, is a species of giant grass. The 40-foot Joshua trees of Southern California are actually giant lilies, and the huge fern trees of Java are only a larger, tougher type of ordinary forest fern.

In developing trunks and branches, the earliest trees formed a single stem rising straight from the ground, with branches going out horizontally and becoming shorter toward the top, in the manner of pine, spruce, and hemlock. Not until the development of the angiosperms did trunks learn to divide and redivide into branches. This brought variety and many types of trees now exist, each with a characteristic angle at which its branches grow and its trunk divides. The maple grows branches in pairs and establishes a balanced symmetry. The oak spreads its gnarled limbs haphazardly either in curves or abrupt angles in response to the wind.

Oak, hickory, and walnut trees have taproots that spread out under the earth in a mirror image of the branches and trunk above ground. Each has a central shaft that descends like an inverted trunk, throwing out branches that, in

28

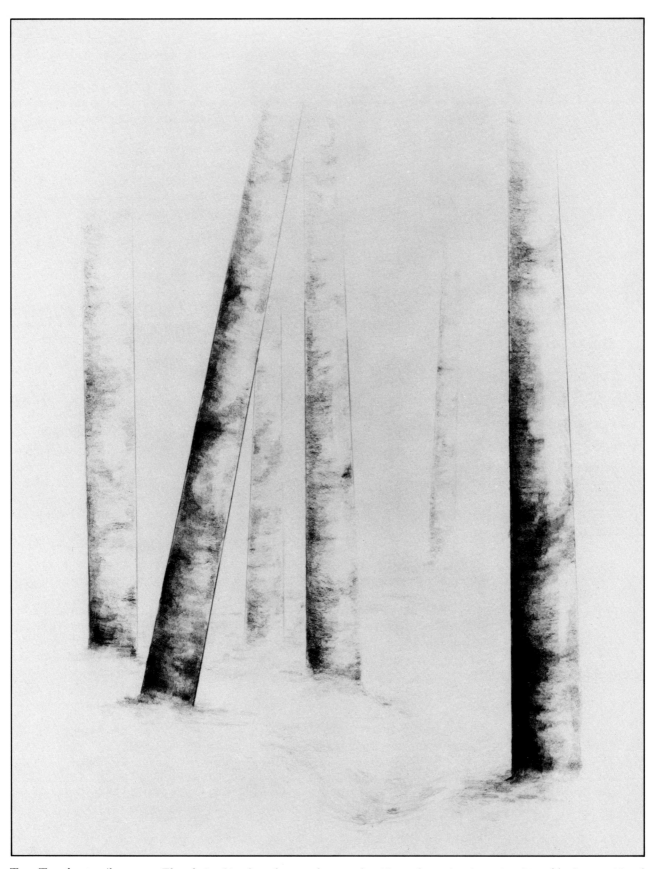

Tree Trunks, *pencil on paper. The relationship of tree forms and space, of positive and negative shapes, is enhanced by the quantities of white used in the trees. Black is used for foreground emphasis, and the distant tree fades into the white paper which becomes space.*

turn, re-branch, each sub-branch carrying a growing tip. A rye plant has been found to put out 378 miles of roots in four months (an average of three miles a day) in the course of which it developed 14 million separate roots with 14 billion root hairs. Through its roots and up through its trunk, a tree can lift a ton of water per day. Evaporation through the leaves provides the power to create this lift. A birch tree can have 200,000 leaves, which will release as much as 900 gallons of water on a summer day. As a result, a forest can create storms and alter the weather.

Of all the elements, water seems of prime importance to a tree, yet without its myriad roots wedged in the earth it could not stand. Without sunlight and air, it could not manufacture wood and sugar and bark and oxygen, and all the elements that are essential to its structure. Consider, for example, how the enormous limb of an oak, weighing several tons, can sway in the wind and hold itself up at an angle without falling. What holds it up and at the same time allows it to move? The answer is, in part, water, which is incompressible, which gives the branch its stiffness in the same way as it gives it to the trunk and to the leaves themselves. But the other answer is air, which is compressible, which exists in all the interstices of the wood, and which is compressed whenever the branch moves in the wind. Controlling this movement are the fibers of the wood, which extend through the branch and act in the same way as the cables of a bridge. As the limb sways, and the air compresses, and the water remains firm but nondirectional, the fibrous cables of the branch act as a giant crane to hold it in place. A relatively thin cable can hold up by tension what requires a massive base to lift by compression. This is something man was slow in discovering, and it is the principle which governs the design of cranes and suspension bridges. It is the principle nature discovered long ago, in making trees.

Since we have been involved in representing linear relationships on a flat surface, with the veins of leaves and the relationships of bones in the skeleton of a fish, it seems appropriate to turn our attention to linear relationships in space. In keeping with our concern for the products of nature, trees are an obvious subject for the study of spatial relationships. Trees represent an important type of skeletal system, which has also been one of our major concerns in both leaves and fishes.

For this problem, you will need to go out into the country or to a park where there is a small woods, for you should look at many trees and you should observe the groupings they make and the significance of the spaces between them.

The Problem Draw a group of tree trunks in their natural relationships to one another. Pen or pencil may be used. The drawing should convey a sense of depth, and particular attention should be paid to the varying thicknesses of trunks and to the negative spaces between them. The groupings you select should create a harmonious and interesting relationship on the page, involving both the negative and the positive spaces. Ignore the upper branches as well as the ground itself, so that the drawing concentrates entirely on vertical or angular solids and the spaces between these solids.

The Drawing In this drawing you will not have the obvious advantage of self-contained forms, like leaves and fish skeletons. You will be selecting a small group of tree trunks out of a larger group and cutting them off, in this drawing, below the leaves and above the roots. The centering and arrangement of your drawing will not be simple or automatic, nor will the balance of dark and light elements necessarily hold for the dimensions of your paper. These are adjustments that artists can usually make easily, adding tones where necessary to achieve a balance. But the only way to insure proper placement is, of course, by making a preliminary drawing or sketch.

Take a sheet of paper with you when you go out and perhaps something thick, like compressed charcoal, Conté crayon, or a carpenter's pencil, and divide your paper into small rectangular or square sections. Within each, as you see a grouping of trees that appears interesting, you can quickly sketch their relationships, in thick, thin, broad, and soft strokes.

You should not be concerned so much with the texture of the tree bark or the nature of branchings as with the relationships of tree trunks in depth. There are several ways in which the trunks can be represented. They can be shown as dark masses, as light masses, as outlined forms, or as combinations of these. Therefore, it may be valuable to review some of the traditional ways in which depth can be suggested in a drawing. There are three principal devices: change of size, relative position, and change of tone.

To represent changes in size, a progression of lines gradually diminishing in size, or gradually enlarging, suggests similar units placed at an increasing distance, or moving forward. If this arrangement is combined with the use of a horizon line and a ground plane, and if it also involves the use of vanishing points, the effect is very dramatic.

If there is a horizon line, and therefore a ground plane, then those trees that meet the ground plane higher up on the page than others will seem to be placed farther back. If a tree trunk appears to be emerging from behind another one, it will also appear to be placed farther back.

If strong, dark tones are used to indicate trees in the foreground and paler tones are used to describe those in the intermediate space and in the background, until they fade altogether into the page, an impression of depth will be created. Combining this technique with diminishing size will be doubly convincing. The reverse use of tones is also possible, where the background trees are very dark and the foreground ones gradually become paler. However, the tone of the background becomes important in order to succeed with this effect. Both

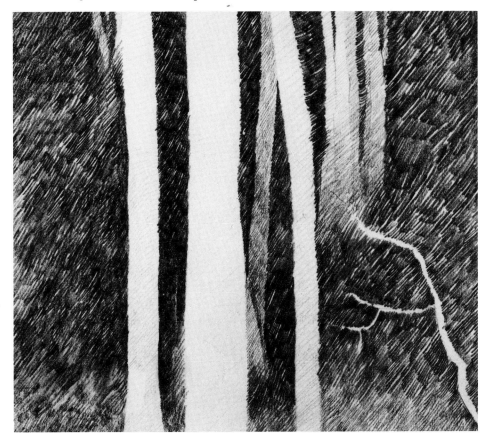

White Trees, *pencil on paper. Here the ground is reversed, with dark tones becoming the distant space. The alternations of black and white stripes create an exciting visual contrast.*

31

systems represent ways of creating what is known as "atmospheric perspective."

If you are going to approach your drawing by using outlines, you should be aware of the possible confusion that can exist between the forms enclosed by the outline and the negative shapes they are supposed to exclude. One way to avoid this is to tone the background, either slightly or heavily. Another way is to tone the trees, or to use shading as a supplement to the outline.

There are also dangers with respect to the use of tones. If you are using atmospheric perspective, with the receding trees becoming darker, you can encounter a conflict with the background if your paper is white, unless the background is thick with trees. If receding forms are progressively darker, then one would expect that distant space itself would be the darkest. This is not always necessary, since light can come from behind as well as from the front, but you run the risk of contradicting the illusion of depth you are trying to create and of flattening a space which needs to be open. One way to avoid this is to darken the background space, or to begin the drawing on dark paper using chalk, white ink, or pencil.

The most common way of using atmospheric perspective is to darken all foreground forms and to allow the receding forms to fade. The ultimate space is then white, which is what your paper usually is.

The Circulation System of Trees

The circulation system of a tree is tremendously intricate, extending from millions of root hairs through trunks and branches to hundreds of thousands of leaves. Its use of water is extravagant. It takes about 55 pounds of water to form 100 pounds of cellulose, yet in making 100 pounds of wood a tree loses 100,000 pounds of water. Part of the reason for this extravagance is to keep the cell surfaces in the leaves wet for the exchange of carbon dioxide and oxygen needed in photosynthesis, but a large part is due to the problem of raising water to the heights required by a tree. This problem may not be apparent unless one realizes that, at normal atmospheric pressure of 15 pounds per square inch, a suction pump cannot raise water higher than 33 feet. Giant Sequoias growing in California can reach a height of 450 feet and have no trouble raising water at a rate of 150 feet per hour.

The ability of a tree to raise large quantities of water against atmospheric pressure and gravity is due to the cohesive character of liquids and to the additional cohesion provided by a narrow space. Water adheres to water in a tube, as it does when being drawn through a soda-fountain straw. In the minute and tight canals of a tree, water moves under pressure of evaporation through the leaves at the top, and the entrance of new water drawn in through the roots at the bottom. With one entrance and one exit, and a waterproof, tight passage in between, water is drawn up with tremendous force — the equivalent of 5,000 pounds of pressure per square inch.

Down at the roots the growing tips push outward in search of water. In front of them is a protective cap, covered with an oily substance that helps it to slide and burrow. The root grows behind the cap, sending out a thousand white root hairs at right angles. These tiny hairs attach themselves to particles of soil and absorb their moisture. All the work of drawing water is accomplished by their actions. As the roots begin to age and the white hairs die they cease to absorb, but they continue to act as conductors. By enlarging, they wedge themselves more firmly in the ground, providing greater support for the tree.

In the economical fashion of nature, trees close down in the winter. They stop absorbing water and sit like cactus in the sun. They drop the leaves which drew such quantitites of water and store the supplies of moisture in the roots, trunk, and branches before the winter freeze. Before they stop, they develop buds where the leaves had been, enclosing sugar and food and a store of ready cells. Rolled like cigars, or folded like fans or parachutes, the embryos of future leaves lie waiting for the spring.

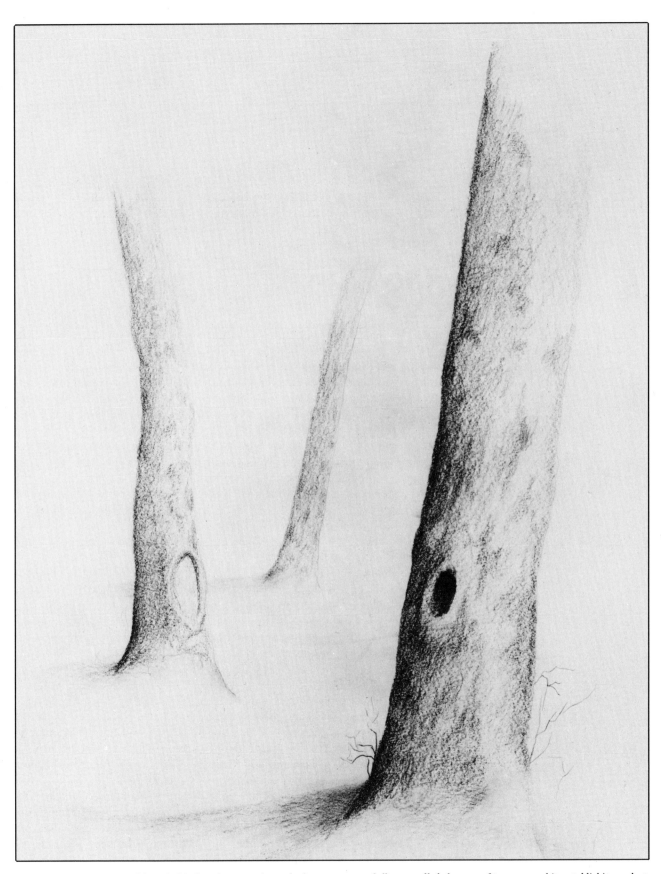

Trees, *pencil on paper. Although this drawing contains only three trees, carefully controlled changes of tone succeed in establishing a deep sense of space.*

4　Eggs

So far, we have been dealing with leaves, trees, fish skeletons — all linear structures whose essential elements can be represented by lines suggesting direction. But nature includes large categories of forms that are not linear but round — solid volumes that are not necessarily directional, but revolve about a point or a plane, or emanate from a core — forms such as pebbles, shells, seeds, and, of course, eggs.

I have chosen to begin with eggs. Of all nature's round forms, they are among the most consistent and precise solid volumes and also have the advantage of being familiar. Certainly, there are pebbles and rocks which imitate the shape of eggs and even the regularity of spheres, and these result equally from the action of external and internal forces — the action of sea and wind and rain, and the chemical structure of stone and sand and shell. But eggs are even more subtle and complex. They are enclosures. They are a product of animate life. They contain living matter.

There are many kinds of eggs, sizes of eggs, colors of eggs. The eggs spawned by a fish can be transparent and microscopically small, while the egg of an ostrich is white and nearly six inches long. Eggs are laid by insects, amphibians, and reptiles, as well as by fishes and birds. It is thought that all eggs were originally white and that evolution has produced the great array of colors and patterns of the eggs of modern birds. Brown, blue, speckled, and spotted eggs are deceptive to predators, while reptile eggs, which are white and leathery, are normally buried or hidden from view, as are those of woodpeckers, which are laid in holes, and of geese, who cover their eggs when they leave the nest.

Insects, fishes, and reptiles generally abandon their eggs soon after they are laid, but birds, with few exceptions, remain with their eggs. They incubate and hatch them and provide for the young after hatching. The slow rate of growth of the vertebrate nervous system and the complicated physiological requirements of warm-bloodedness make this necessary.

When an egg is first laid, the embryo within it remains in a dormant state. The warmth provided by incubation begins the process of development. Some birds lay only one egg, as is the case with penguins. Some birds lay only a fixed number of eggs in one clutch. Some birds begin incubation soon after the first egg is laid; others wait until a full clutch is laid and can produce an indeterminate number of eggs. This can be artificially induced and domestic fowl, like chickens, are bred for this purpose.

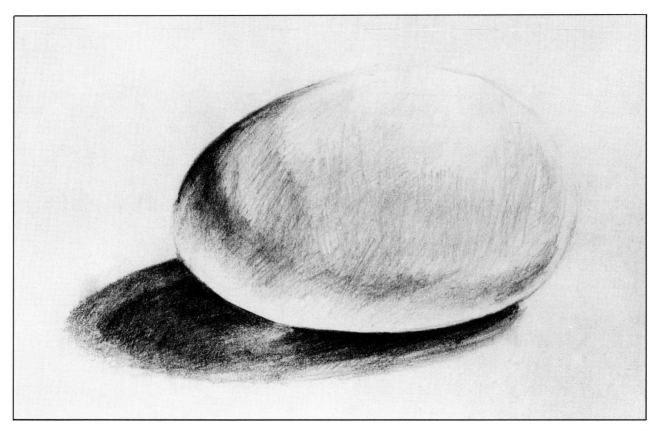

One Egg, *pencil on paper. This rendering makes very straightforward use of pencil strokes. The use of shading and highlights describe all the subtle changes of volume of an egg with great clarity.*

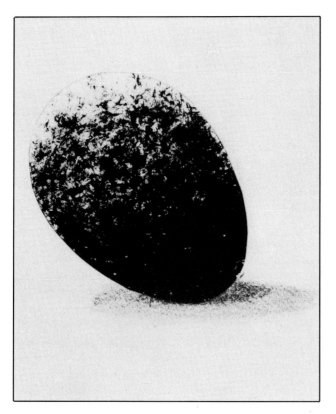

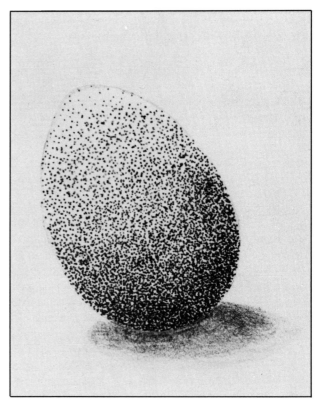

Two Eggs, *pencil on paper. These drawings use marblized dark tones and groupings of dots to accurately describe the volumes of an egg.*

Birds' eggs are laid in the earth, on sand, in open and enclosed nests, on bare tree branches, on rock ledges, as well as on solid ice and snow. They are incubated in dozens of extraordinary ways, reflecting all the inventive variety that nature has to offer.

The male penguin incubates the one egg laid by the female by holding it between the top of his toes and the bottom of his stomach, and he does this for as long as two months in the arctic winter, without moving and without eating. The fairy tern lays a single egg on a bare branch. The piping plover makes a slight depression in the sand and lines it with bits of sea shell. The chimney swift glues twigs together with its own saliva. The crested flycatcher lays eggs in the natural cavities of trees, while the downy woodpecker excavates its own hole in a tree. Kingfishers dig nest burrows in earthen banks. The nest of the African hornbill is in a tree cavity or rock crevice, which the hornbill seals nearly shut with mud during the incubation period with the female inside. The male feeds her through a tiny slit. The mallee fowl of Australia accumulate mounds of decaying vegetation in which they deposit their eggs. They then cover the mound with sand and abandon their eggs to be incubated by the heat of fermentation. Babbling thrushes build community nests in which the duties of incubation and care of the young are shared. Colonial weaverbirds build adjacent nests under a common canopy and live, several hundred together, in what amount to apartment houses.

There are other birds, such as the European cuckoo and the Argentine black-headed duck, who habitually lay eggs in the nests of other species and leave it to the foster parents to hatch and rear the young. This is referred to as "social parasitism" and exists in other forms in other species, including the human. I have seen a remarkable picture of a tiny garden warbler mother dutifully feeding a young European cuckoo three times its size. Many birds do not recognize their own eggs, and herons and gulls have been known to incubate, or at least attempt to incubate, light-bulbs.

Although the eyes of most birds are, in fact, sharper than those of humans, one of the basic requirements of the artist is the ability to discriminate between light-bulbs and eggs!

The Problem

Briefly, the problem for this chapter is to draw six views of the side of an egg in six different ways. You may use a pen or a pencil, but not both. You may use any kind of egg, but a chicken's egg will do very well.

There are two important aspects to this problem: (1) to have you examine with care and attention the particular three-dimensional volume which is an egg (its exact shape, dimension, and appearance in light and shadow and in space), and (2) to introduce you to at least six ways in which such a volume in space can be described in two-dimensional ways.

The Drawing

The most obvious way to draw is to work with an outline, to follow the outside contour of an object: this is certainly one of the six ways to approach this problem. Tone and shading are also available. You can use charcoal, or the smudge of a pencil, or fine hatching lines in pencil or ink, or a wash applied with a brush for the shadows cast by and on an object. All these methods are very effective ways to indicate the shape and form of an egg.

You can also combine the two methods by using shading and an outline. Let me suggest that in drawing an outline, the quality of the line itself can suggest the closeness or distance of an edge in space, and by exaggerating these differences the subtle rounding of a shape can be suggested.

Another method is the use of a spiral line. If you look at some of the drawings of Rembrandt, or Leonardo da Vinci, or Titian, you will notice how frequently and effectively they make use of a spiral line to indicate rounded

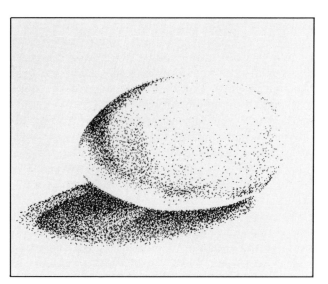
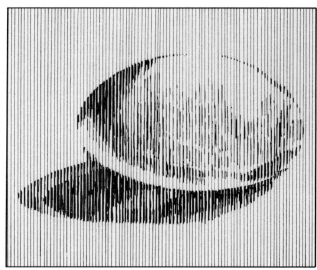

Drawing of Two Eggs, *ink on paper. Both dots and parallel lines are used with precision to render three-dimensional form.*

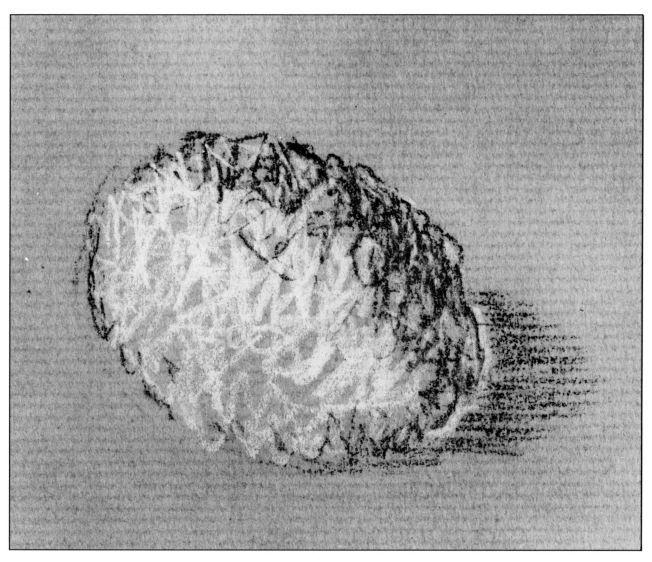

Scribbled Egg, *charcoal and chalk on gray paper. Irregular lines can be used effectively to describe a shape. The open spaces between lines help to suggest a volume.*

forms. It requires some practice to make successful use of spiral lines; Leonardo's sketches are full of the marks of such practice. A spiral line can and does suggest a round shape, and has the advantage of suggesting direction clearly. Rembrandt frequently uses it, not only to indicate the roundness of a wrist or an arm, but also its direction in space. The imaginary center of the loops suggests the direction of thrust, and this method can be used to draw an egg.

Another, more subtle method involves the use of patterns, through the suggestion, in a sense, of texture. You can use fine dots, little crosses or hatch marks, and by the spacing of these marks — close together in the middle, spreading out at the edges, or vice versa — you can suggest roundness and shape. The same can be done by the gradual enlarging or darkening, or diminishing and lightening of the patterns.

I would like you to use all these principal methods, and combinations of these. Again, let me suggest the six possible drawings: a line drawing, based on the outline of the egg, but using all the resources of line variations, thickness, thinness, or doubling at the edges; a drawing limited to shadow tones only, in charcoal, pencil, or wash; a drawing using shading, but limited to the use of a finely controlled line used for hatching, in ink or pencil, using a fine point; a drawing combining contour line and shading; a drawing using spiral lines only; and finally, a drawing using pattern or texture marking to suggest the roundness and modeling of the form.

Eggs

An egg shell is a hard, calcareous, extraordinarily lightweight, and enormously strong structure — one of nature's unique creations. It is manufactured by the secretion of a substance from a special gland in the oviduct of a female bird in a period of less than 24 hours.

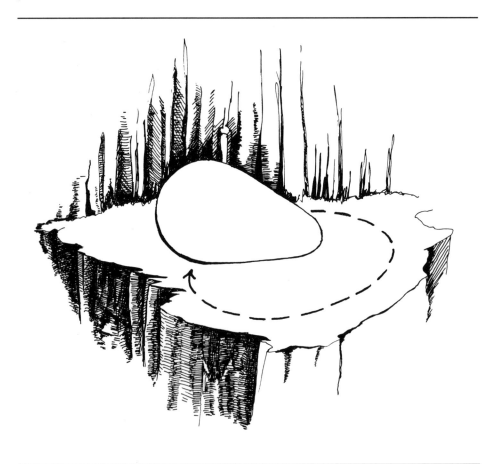

Figure 8. *A murre egg on a cliff ledge. The center of gravity lies forward of the point of contact of the egg's surface, so any movement results in a return to the point of departure through a narrow arc.*

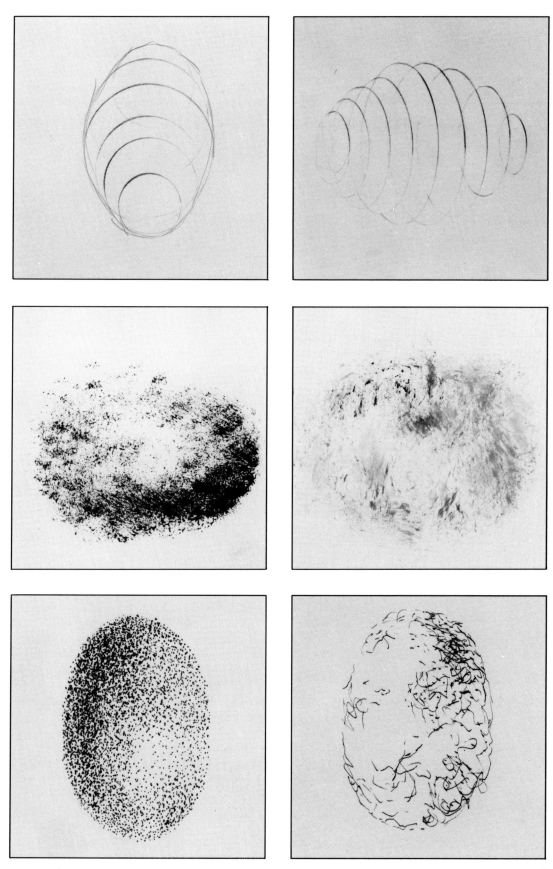

Six Versions of an Egg, *pencil and ink on paper. Regular and broken lines, tones, dots, and smudges are all used here to describe form and volume.*

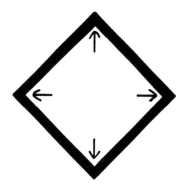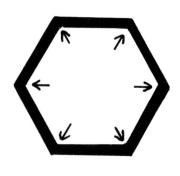

Figure 9. *A piece of string as it reacts to the pressure of equal forces forces – acting in four, six, eight, twelve, and an infinite number of opposite directions.*

A bird's egg is never spherical nor uniformly elliptical, and in this it conforms to Henry Moore's observation of nature's forms as having lost their perfect symmetry in reaction to environment, growth, and gravity. D'Arcy Thompson has said, "The sphere is. . . of all possible figures, that which encloses the greatest volume with the least area of surface; it is strictly and absolutely the surface of minimal area." For an organism to be spherical, however, it must have a homogeneous environment and must be subject to symmetrical pressures. Again, in D'Arcy Thompson's words, "The essential conditions of homogeneity and symmetry are none too common, and a spherical organism is only to be looked for among simple things." An egg is no simple organism. Eggs are subject to gravitational forces, to the pressure of passage through the oviduct of the female bird, to the needs of fitting with others in a nest, and to the needs of the growing embryo within them.

An interesting aspect of the shape of an egg is illustrated by the pyriform, or top-shaped, eggs of cliff-dwelling birds, which are only slightly more elliptical and elongated than the eggs of most birds. The murre, for instance, lays one egg on a cliff-ledge without nesting material, and its shape insures against its rolling off (Figure 8).

The egg sits on its somewhat spherical end, while its center of gravity lies beyond the vertical at its point of contact. If it rolls, it will move in a very narrow arc related to its center of gravity. Most eggs, in fact, have this tendency to roll in a discreet arc.

The enormous resistance to crushing that is built into the shape of an egg is worth a few words of comment. You should satisfy yourself as to this enormous strength by holding an egg in the palm of one hand and squeezing with the fingers of that hand only. The egg cannot be crushed. Nor can it be crushed if you hold it end to end in the palms of both hands and exert all the pressure you can. This strength relates to the design of circular and parabolic arches.

A circle represents the ideal shape for dealing with an infinite number of tension forces acting on an enclosed surface. To observe this, take a piece of string or wire and fasten the ends to form a closed loop. If you push against it in four opposite directions with equal force, it will form a square. If you apply six forces of equal pressure, it will form a hexagon, eight points an octagon. It should now be easy to see that an infinite number of pressure points will form a perfect circle.

By the same token, the shape that will best resist an infinite number of compression forces acting from the outside is a circle. The Romans understood this in the design of their arches. Now the egg, in any longitudinal cross-section,

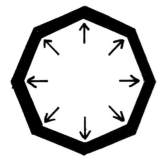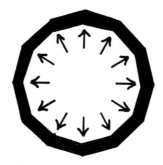

is a perfect circle, and it will resist very effectively an infinite number of compression or tension forces applied equally along its circumference.

The circular, or Roman, arch is, interestingly, not the most efficient structure for resisting tensions or for supporting pressures that are uniformly distributed in a horizontal direction. It is instead a parabolic curve in which, for optimum strength, the sag is equal to one third of the circumference (Figure 10).

A catenary curve, on the other hand, results from loads equally distributed, not in the horizontal direction as in the parabola, but at points equally distributed along the surface of the span. It is a slightly more elongated parabola. It will, of course, be immediately noticeable that an egg contains both these general shapes, one at each end. These are curves which represent the ideal compression spans for resisting certain kinds of vertical forces, as worked out by the calculations of engineers. They were derived not from eggs but from studying the action of tension forces on steel cables for bridge-building purposes.

In summary, the strength of an egg shell derives from the shape of the parabolic curves of both ends, which are most effective in resisting vertical pressures that are not continuous, while at the same time, the lower ends of these parabolas absorb the tension pressures as equally distributed loads acting on a circular arch.

Incidentally, it can be deduced from a study of the catenary and parabolic arches that it is the thinner, catenary end of the egg which emerges from the chicken first.

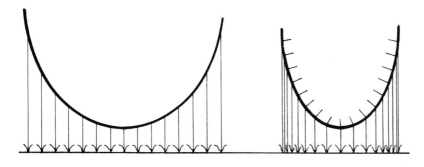

Figure 10. *Parabolic and catenary curves, showing the location of formative pressures. In the parabola, forces are distributed equally along a horizontal line. In the catenary curve, the forces are distributed at equal intervals along the curve.*

5　Egg Constructions

"A dreamer can make eggs as big as houses dance. . ."
Jean Hans Arp

Now that we have examined the shape and structure of an egg and tried the different ways of representing its curved surfaces on a flat plane, let us examine what we can do with it as a construction in space — as a structure made, not by oviducts, but with the hands and eyes and the rather crude materials of an artist.

An egg is a space enclosure. In contrast to our last three-dimensional problem, where lines were used to suggest planes and directions in an open and indefinite space, an egg shape is self-contained and deals with space as something within itself. This would seem to present rather limited possibilities for three-dimensional exploration. Indeed the possibilities are limited, but they nevertheless exist, and it is on limitations that art thrives.

There are two rather obvious possibilities for dealing with a self-contained enclosure. One is to treat it as an air-filled space, such as a balloon or a sealed glass (one flexible, the other rigid). The second would be to treat it as a packed solid, such as an egg-shaped lump of clay or plaster, or even an old sock packed with paper. In both cases the visual interest lies entirely in the outside shape. Neither the enclosed air nor the packed clay or plaster nor the paper serves a visual purpose in itself except to uphold the outer shape. And we must face the fact that as an artistic construction, an egg shape, which is an imitation of nature, can have only a limited interest in terms of form. It is obvious then that if it is to have any real visual interest it must come from the structure and not just from the form alone.

Of the solutions mentioned so far, it would seem to me that only the old sock stuffed with paper suggests anything of interest beyond the outer form. At the very least, its outward appearance would be less imitative than a lump of clay or a solid piece of wood. It would probably be irregularly stretched and slightly lumpy, so that something of the inside structure would at least be suggested. Even so, it would hardly be overwhelming as an experience, yet it is a start.

You are probably familiar with the Russian or Polish Easter eggs which open lengthwise to reveal another egg, which in turn contains a smaller egg, which also holds an egg, etc. Unfortunately, to appreciate such a construction it is not enough just to look at it. You have to open and open again. Or you might place them all side by side and marvel at their diminishing scale and proportional similarity. This is not without some interest. It does at least fill the mind with thoughts of change, with a sense of the meaning of scale, with an understanding of the interrelations of convex and concave shapes, and of how things fill. This is

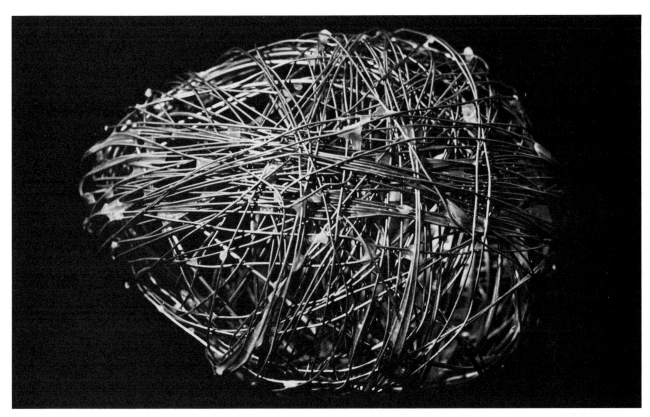

Coiled Egg, *wire and lead. This very alive egg volume can be separated like a Chinese puzzle.*

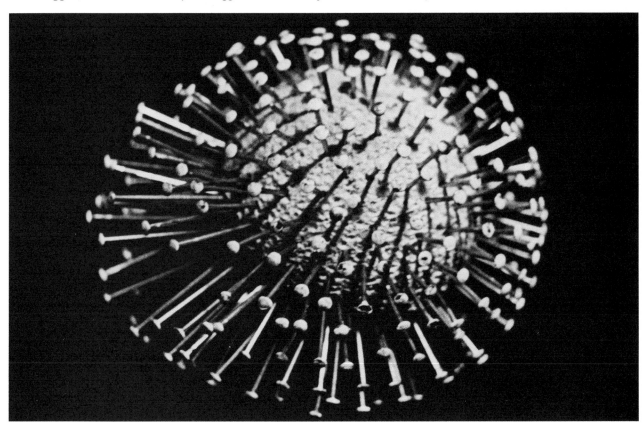

Nail Egg, *rubber and nails. The nails are set in a rubber ball to different depths, suggesting the relationship of the embryo to the outer shell of an egg. It bounces.*

no small order of accomplishment. Unfortunately, however, each enclosed volume remains a copy of the previous one, and each remains simply a shell imitating an egg's form.

I believe that somewhere between the Polish egg and the stuffed sock, or in some combination of both, there exists a clue to the solution we are seeking: how to make an interesting construction that fits the shape of an egg.

From the Polish egg we have the idea of fitted things; from the sock we have the idea of accumulated things. Could we accumulate a group of shapes that would also fit together, and in fitting together recreate the shape of an egg? I feel the answer lies in a method of construction known as lamination (or accumulation): this means the joining of planes to achieve the desired shape or thickness. There is some connection between this method and certain processes in nature where growth follows from the multiplication of cells, from the interlocking of organisms, from the adhesion of related materials.

Figure 11. *Some imaginary contour lines as they pass through an egg seen from the end view.*

Lamination may have some further relevance in connection with our use of looped and spiral lines for drawing round volumes. Snails, conches, and mollusks generally form their shells in continuous spirals, and the same sort of spirals determine the residual formations of the horns of mountain goats and the tusks of elephants. Looped lines, like the growth marks of cut tree trunks, also designate elevations on maps. The contours represent regularly spaced intervals of height, and if an egg were represented in this fashion it would look something like a series of almost regular concentric circles, very close at the edges and far apart at the center (Figure 11).

This is also what the end view of an egg would look like if it were made of regular laminated sections of equal thicknesses. This method has the beauty of suggesting the process of accumulation by which growth occurs. It does so in a purely visual manner. At the same time it avoids the obvious, which can only be an imitative solid volume or a hollowed-out space.

But the process of lamination itself is only one way to create an accumulation or to subdivide a volume, and I will ask you to search for other and more interesting variations. Among other things, lamination implies the fixed adhesion of the accumulated parts, and it seems to me that the structure would be far more interesting if the parts could be separated or joined at will, in the manner of Japanese puzzles.

The Problem

Stated as simply as possible, the problem is to make an egg, or a construction approximating the shape of an egg. It should consist of assembled sections that can be separated or joined at will. It may be of any size and of any material.

The Construction

I have mentioned Japanese puzzles — those spheres, cubes, and other shapes made of wood — which consist of many small parts, varied in size and shape, and fitting together in quite unpredictable directions. They are an interesting example of a type of accumulation quite different from lamination. They have, however, one defect from our point of view. This defect is precisely their virtue as puzzles: the parts have no meaningful relation to the whole. Not simply in our capacity as amateurs of nature's ways, but in our roles as artists, a lack of relationship is equivalent to a lack of purpose or as artists would prefer to say, a lack of meaning. From the very beginning, nature accumulates forms in ways that represent the most economical method for producing its finished shapes. In a similar manner, Arshile Gorky, the painter, said that one should be able to look at an isolated square inch of a painting and deduce from it the manner, spirit, and feel of the total picture. The method of Seurat, in relating greens to oranges and in building up sections of his paintings through the consistent use of small dots representing complementaries, is another form of the same idea. Artists build, as nature builds, by the simplest and most consistent means to achieve an

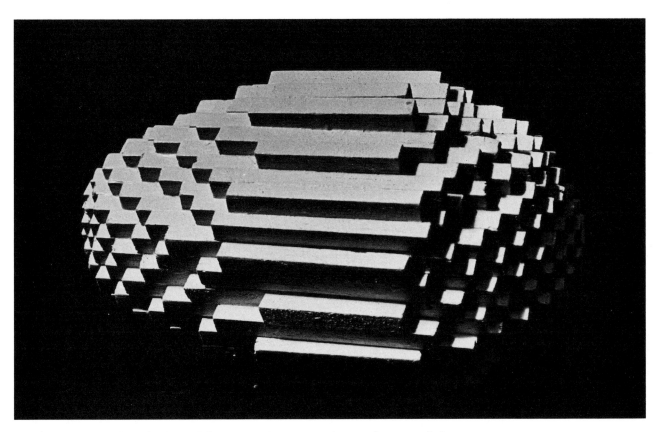

Wooden Egg, *painted wood. This modular construction separates in several unexpected places.*

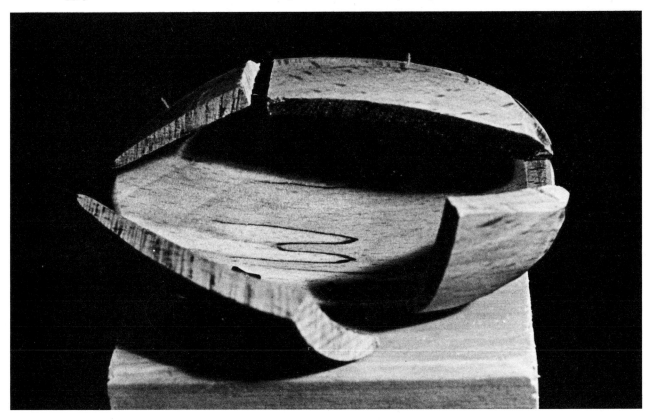

Egg with Doors, *wood and metal. This construction closes tightly into the shape of an egg, and opens in an unexpected way by the use of tiny hinges.*

intended purpose. Lack of meaning, lack of purpose, lack of direction represent failures in art. Therefore, let the forms you build for this egg have a logic and a relatedness consistent with your ultimate purpose.

This brings up a related problem: the use of materials. Something can be said for mixing and combining materials: some beautiful rocks, medieval strong-boxes, the Cathedral of the Sagrada Familia in Barcelona are ample witness to this, but it can be extremely tricky and dangerous. It can, again, help to confuse the sense of ultimate purpose which your construction should have. I therefore recommend you choose just one material — whether wood, cardboard, plaster, or metal — that inspires you most in relation to the shape you are attempting to create and to the process you will have to follow.

Some might begin by making a solid in the shape of an egg (which is perfectly valid) and then will slice it in various ways into smaller fragments. Some will slice lengthwise and some widthwise, some into regular divisions and some into irregular divisions. Any of these approaches is acceptable. Just keep in mind that a certain consistency in method is important; the best works will be those where the separated shapes have some essential relation to each other as well as to the total shape — the egg shape — which they create.

Please do not allow the smooth surface of the egg to influence you. We are not imitating here, we are creating, or recreating an idea — not a specific object.

Others might approach the problem not by slicing a solid, but by assembling materials of various kinds to combine into an egg shape. This too is valid. Again, a certain consistency in the assembled elements must be considered, and the way in which they combine to produce the ultimate egg shape must seem natural — not like taking a lot of paper balls and tying them or crushing them into the shape of an egg. A wad of string may have a legitimate interest; an egg structure made of paper balls may be entirely valid. It must seem valid, however. It must seem inevitable.

The construction that will be most successful, in my opinion, will cause you to marvel that its separate parts can come together so inevitably into the shape of an egg. At the same time, the method of joining the parts is of such intrinsic interest that you are made to think not only of eggs but of the joining systems of all related structures.

Art is exciting when you have the feeling that a work of art has to be as it is and cannot be any other way. Nature has this quality. Mechanical objects have

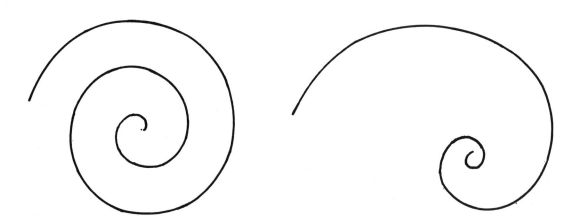

Figure 12. *Two types of spirals: an equiangular spiral and a spiral of Archimedes.*

this quality, too: they work. Art does not have an obvious function and, if it is to avoid becoming mere decoration, it must convey its own sense of necessity, of inevitability.

At the same time, a great work of art must be full of analogies — a shape that makes you aware of many shapes and therefore becomes a measure of all shape; a color that makes you aware of color and therefore of all colors. In our problem, which is a joined or jointed structure, we must become aware of other joinings, of other joints, of all processes by which things are joined.

We have spoken of circular and of spiral lines as a way of drawing round volumes, and we have seen how these lines themselves also suggest a way of constructing solid volumes according to the procedures of lamination — by adding related units together. I feel that before going on to other matters it may be of interest to consider certain aspects of spirals, especially the spiral that occurs in a number of nature's forms: the equiangular, or logarithmic spiral. The other general type of spiral, simpler and less interesting, is known as the spiral of Archimedes. In the equiangular spiral, the radius of each revolution grows in geometrical progression; in the Archimedan spiral, the radius of each revolution grows in arithmetic progression (Figure 12).

The equiangular spiral is related to the "Golden Section" and has other interesting mathematical and geometrical properties that I will discuss shortly. First, I would like to say something of its appearance in nature, as it bears specifically on our egg construction problem.

In nature, the equiangular spiral exists in permanent form in the nautilus shell and in molluscan shells in general, in elephant tusks, beavers' teeth, cats' and canaries' claws. In all these cases the spiral is formed by stuff deposited or secreted by living matter. In the words of D'Arcy Thompson, these forms "all grow, as an edifice grows, by accretion of accumulated material and, in all alike, the parts once formed remain in being and are thenceforth incapable of change."

Whereas living matter is generally in a continuous state of change and tends to grow in all directions simultaneously, the special character of shells and horns and tusks is that they grow from one end only. The result is that one end is "dead," so to speak, while the other keeps "growing," so that all of its stages of development remain a visible part of the final structure. In reality, the parts increase and accumulate rather than grow, and the dead cells of which they consist are by-products, "formed material," cast-off, or carried, or lived in by the animal that shaped it.

What remains particularly fascinating about the fact that this cast-off material takes the form of an equiangular spiral is that this shape, almost more than any other, suggests growth, process, time, and change. For all the permanence of those structures that nature forms into a spiral, this shape remains an extraordinarily visual image of change. And the reason for it is that it is never, and can never be, finished. Not only is it forever enlarging, but it is enlarging in a fixed relation to its beginnings, and it always appears to have the capacity for never-ending development.

There exists in geometry a term derived from the Greek and called a "gnomon." If you take a square and add to it an L-shaped unit made of equal parts, as in Figure 13, so that the result is a still larger square. This L-shape is called a gnomon.

Similarly, there are three types of gnomons which can be added to a triangle, or cone, so that the enlarged figure remains proportional and otherwise identical to the original. This is, in general, the same principle by which spiral forms grow. The units that are continuously added, in ever-enlarging proportions, are gnomons. They add and enlarge without ever altering the original form (Figure 13).

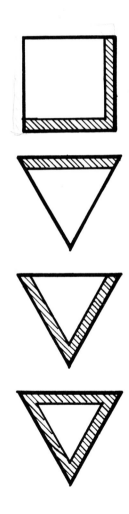

Figure 13. *Four gnomons: three can be added to a triangle, only one to a square.*

47

We all know that the Greek letter π (pi) has a mathematical value of 3.1416, but non-mathematicians are not likely to know that the Greek letter φ (phi) also has a mathematical value, which is 1.618 etc. This value has an interesting relation to forms in nature, to mathematics, and to spirals. There is, for instance, a series of numbers known as the Fibonacci series, which goes this way: 1, 1, 2, 3, 5, 8, 13, 21, 34, etc.

If you examine this series for a moment you will see that each number is the sum of the two previous ones, and it is obvious that the numbers will soon grow very large, in the manner of our logarithmic spiral. What is not obvious, however, is that if you divide any number in the series by the previous one, the result is always approximately 1.6! But there are more serious occurrences of this magic number. If you take a pentagon in which each of the five equal sides is given the value of 1, then the dimensions of each of the five diagonals will be 1.618, or phi (Figure 14). The pentagon, of course, is basic to many of nature's forms — a fruit blossom, for example, always has five, and only five, petals.

The value of phi is also related to the Golden Section — considered by the Greeks to be a rectangle of perfect proportions. This rectangle has a ratio of 1 to 1.618. The curious aspect of this proportion is that if you construct such a rectangle and then attach a square to the longer side, the new rectangle formed retains the same proportions (Figure 15). If you then continue the process, by adding ever more squares, you have the basis for drawing a perfect equiangular spiral (Figure 16).

It is now evident that each square added to each equally proportional rectangle is in fact a gnomon, and the additive properties of gnomons correspond precisely to the natural formation of spirals. Sea shells grow by additions which are always proportional in scale, in direction, in form, and by this accumulation, this accretion of materials, create a permanent record, which is also a perfect image of change.

Figure 14. *A pentagon. The dotted lines represent the hypotenuse of each of the five potential triangles. The hypotenuse is related to the sides in the ratio of 1.615 to 1.*

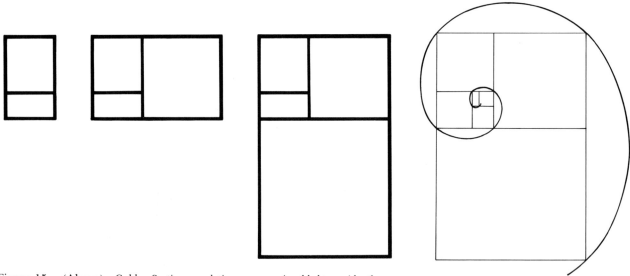

Figure 15. (Above) *Golden Sections: each time a square is added to a side, the rectangular proportions remain in the ratio of 1 to 1.615.*

Figure 16. (Right) *An equiangular spiral drawn over six developments of the golden section.*

Painted Egg, *painted acrylic foam and rubber. This acrylic egg separates in differently shaped and colored segments. Inside, acting as a yolk, is a rubber ball.*

Egg Construction, *acrylic resin and wood. These irregular sections of acrylic resin can be separated, or held tightly together by a central shaft of wood.*

6 Seed Pods

"Isn't it odd," I said, as we were looking at the roses with those ladies, "to think that flowers are the reproductive organs of the plants they grow on?"

Logan Pearsall Smith

Land plants — all the trees and bushes with which we are familiar — grew from the sea. So did the animal world. The animal and vegetable worlds are, in a sense, two aspects of the same principle. Animals move, plants stand. Animals digest internally, plants externally. In their joint origin among the plankton of the sea, they were the same. Simple, single-celled creatures, swimming about in search of food, reproducing by contact with each other, drawing energy from the sun — they are, in their origins, indistinguishable from each other. Some began to grow together and to retain, as a group, the mobility of the moving single cells; others united in a passive mass, depending on the sea for movement, and attaching themselves to protruding rocks in search of more light.

Seaweeds are the origin of plant life on land, yet they retain a sea existence, absorbing nourishment directly from the water, like fish and plankton, and reproducing by releasing cells back to the sea. Developing footholds, growing stems, spreading fronds outward to the sun, seaweeds began their evolution into land plants. Fish and weeds together established a foothold on the land, adapted to the air, developed their interdependence, prospered, and spread.

The principles of growth and change in nature seem to be based on the establishment of two parts, two dependencies, two complementary and supplementary wholes. Animal and vegetable, earth and water, hot and cold, male and female, two-legged, two-winged, two-eyed, all began with two cells united, two chromosomes combining, two opposite elements meeting to initiate the cycle.

In plants, much as in the animal world, the most common method of reproduction involves the fertilization of an egg by a sperm. Since plants are not independently mobile, the fertilizing sperm is carried to the egg by wind and water and insects. The egg is carried in a flower.

Flowers are so varied in their appearance, and the differentiation into male and female parts is so often invisible to the casual observer, and the flowering of some plants is so unobtrusive, that we are not often reminded of their reproductive importance. In addition, many plants produce seeds, nuts, and fruit so extravagant and so varied that their connection with a flower, long faded, is often forgotten. Yet all seed production begins with a flower, and the least visible structure of the flower is the basis for the appearance of the fruit. It is not always easy to remember that a strawberry, a squash, a pea pod, a nut, or an acorn are, in fact, types of eggs carrying fertilized seeds — embryos awaiting the time, the warmth, and the moisture to begin growth.

Cucumber, *pencil on paper. Details of texture and the placement of sections give this drawing a very strong visual impact.*

Spherical containers are common forms for the protection and containment of plant seeds, just as eggs are common for the protection of animal embryos. Since we have become involved in the representation of rounded forms, it would seem appropriate to focus our attention on those seed-containers which are rounded in form and to select one for a drawing. Unlike eggs, they have the interest of variety of shape and irregularity of surface. They are more eccentric, differentiated, and complex, and they present greater interest as a drawing problem.

Just as it seemed important in drawing an egg to understand something of its function and to appreciate the realities of its construction, it seems to me that if you are to draw the outer form of a seed container with any understanding, you should know its purpose and its burden. The first step in understanding is to look. Therefore you are going to be asked not only to draw the outer form, but to analyze and dissect and to draw the inner contents of the container you select.

You should be aware that the terms "seed pod" and "seed container" have no scientific sanction. In botany, the word "fruit" is used to denote any form of seed container, or cluster, produced by a flower. Unfortunately, this is not the common understanding of the term. Few people are aware that tomatoes, squash, cucumbers, corn, and eggplants are fruits; that grains of rye, wheat, barley, oats, and rice, the samaras of elm and ash and maple, the nuts of chestnuts, hickory trees, and oaks are also fruits. While olives, cucumbers, and peppers are fruits, cabbage and cauliflower and celery and rhubarb are vegetables. A vegetable is a plant whose edible parts are not those produced by a flower.

Many classifications of fruit exist in botany. Follicles, legumes, achenes, grains, samaras, and nuts are dry fruits. Berries, drupes, false berries, and pomes are fleshy fruits. In addition, raspberries, strawberries, and blackberries are aggregate fruits, while pineapples, mulberries, and figs are multiple fruits. Tomatoes, eggplants, and red peppers are berries. Oranges, lemons, and grapefruit are modified berries. There are reasons for these classifications and they are very fascinating. However, we are not botanists and the language of botany is regrettably different from ordinary usage. Therefore, it does no harm to occasionally use the term "seed pod" or "seed container" or, in its broadest sense, the word "fruit."

Fruits generally contain an outer shell, a core, a seed enclosure, and a seed or seeds arranged in a particular way. The arrangement is inherent in the base of the flower from which the fruit developed. The seeds can be single, double, or multiple, free-floating, encased in chambers, and attached to the inner or the outer walls of the container. The container can be hollow, double-walled, ridged, filled with pulp, or empty. Since the structure of the ovule of the flower in part determines the shape of the fruit, the method of pollination of the flower must also affect the fruit. In turn, the fruit must provide a means for germination and propagation of the seeds. There are many ways in which this can be simply accomplished.

Seeds must be propagated in such a way that they will germinate away from the parent plant, so that adequate light, water, and nourishment will be accessible. One obvious advantage of a round shape is that it can take advantage of sloping ground by rolling. Fleshy fruits hold nourishment that can assist the plant in its early growth, independently of favorable conditions of the ground. On the other hand, dry fruit and nuts can retain seeds in a dormant state, protected for long periods, until favorable conditions develop. A coconut can float, airtight and dormant, until it reaches the sandy shore of a distant island. Flying seeds, or samaras, can be borne by the wind long distances from the parent plant. The seeds of edible fruit can be carried far away by animals, including men, or eaten and digested and placed in fertile ground by this process. The dry pods of some fruit will break open suddenly, scattering seeds for

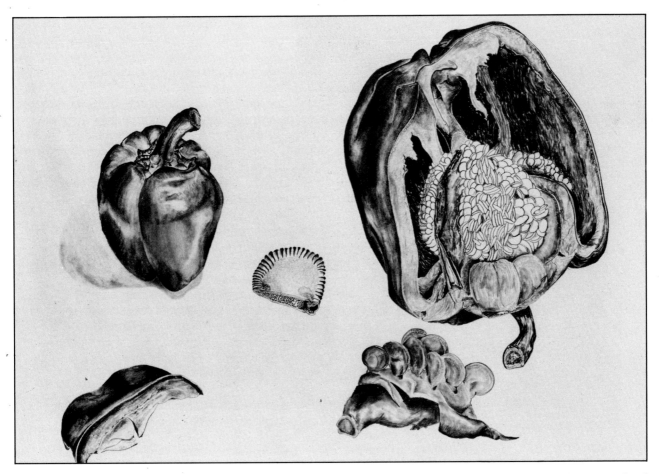

Green Pepper, *pencil on paper. The shiny, reflective texture of the pepper is rendered with a masterful control of tones. Sectional divisions have been very well chosen.*

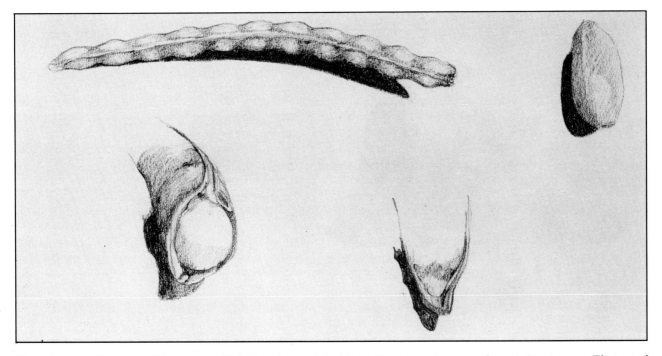

Green Pea, *pencil on paper. The unexpectedly dark shadows and the delicate drawing create a sense of a mysterious presence. The pea pod appears to be advancing like a hungry snake.*

several feet. At the right moment the fruit of the dwarf mistletoe will burst due to a change in its internal pressure and send a seed 50 feet through the air. For these, and other reasons, fruits come in many shapes, types, and textures — dry and fleshy, hard and soft, round and flat and elongated, delicate and heavy, attractive and ugly, or unnoticed.

For this problem I urge you to examine the wide variety of fruits available before you make a selection. Although you should make the choice, selecting a fruit of rounded or spherical character will give you an opportunity to further your ability to represent volumes on a flat surface. Although there are many others to choose from, apples, peppers, pomegranates, melons, and acorns would present excellent shapes for drawing. As much as possible your choice should be based on the interest and the excitement it arouses in you.

The Problem
Select a seed container, preferably rounded, and render its outward appearance. Then draw a sectional view, carefully selected to insure the clearest revelation of the arrangement of the seeds. Finally, render the shape of the smallest seed, enlarging it if necessary.

Your drawing should consist of at least three parts, but so placed on the paper that they appear to have some meaningful relationship to each other. You may need to select three examples of the fruit so that you can retain one for the outward appearance and cut the other two, experimenting with the most appropriate cross-section for the sake of the clarity of your drawing. The smallest seed should also be rendered with care.

The Drawing
You may choose a variety of ways to render the fruit and the seeds. Whatever method of drawing you choose, however, should be consistent for the three essential parts of the drawing. The rendering of tones and the use of shading will probably be most useful to you. At the same time, you will need to consider the textural qualities of each part. The outer skin may be smooth and shiny or rough and irregular. The cross-section may involve soft and hard parts. The seed itself will seldom be of regular shape and may be smooth or rough. The character of each part should be carefully rendered in your drawing.

In rendering the cross-section and the outer form of the container the temptation will be great to depend too much on line and outline. The danger is that these lines will destroy the illusion of roundness and depth unless they are carefully varied in intensity and related in character to the quality of the shading you use and to the type of textural effects you become involved with.

As in rendering any rounded shape by the use of tones, it will be important to establish the extreme and middle limits of the tones to be used, the darkest darks, the highlights, and the middle values.

Cennino Cennini, in the 14th century, wrote a classical treatise on painting in which he described, among other things, "How to paint a young Virgin." It remains, to this day, a clear description of how to apply a very direct and basic technique. After establishing the outline of the face, you take a bowl of ochre, black, and white, and mix it thoroughly. With this mixture you establish your middle values. You then pour a quarter of the mixture into each of two other bowls. To the first one you add white, to the other you add black. You have now established your dark, your light, and your middle values. You apply the middle tones to the surface of the face first, then you apply the light. Afterwards you work on the shadows, using the dark, returning eventually to the middle value to smooth the transitions. You then add red to the lips and pink to the cheeks and you say three "Hail Mary's." After this, you are done. Pencils can be controlled in much the same manner as tempera and even if you elect not to say the Hail Mary's then, at least, pause between the application of each tone and reflect. You cannot miss.

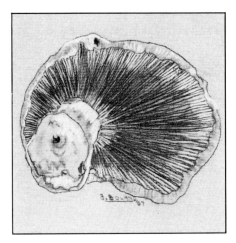

Mushroom, *pencil and chalk on gray paper. Though a fungus and not a fruit, this spore-producing mushroom is rendered with great clarity and beautiful precision.*

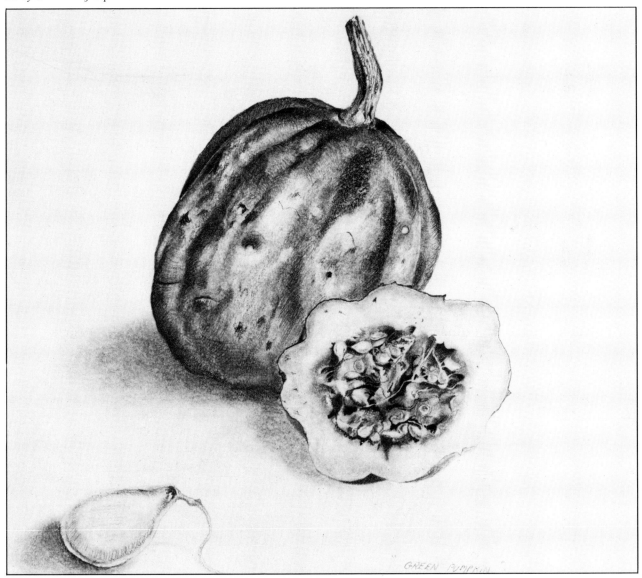

Green Pumpkin, *pencil on paper. The pumpkin texture, the pulp, and the seed cavity and seed are rendered in similar tones, yet the character of each part is clearly identified.*

You will need to give some thought to the methods of rendering textural effects, and some experimentation may be called for. For example, if you hold your paper over various surfaces and rub it with a pencil, you will immediately obtain a dozen suggestions for ways of creating textures. Using an eraser, a pen knife, and pencils of different hardness and sharpness, and letting them cross over each other in various ways, scratching and rubbing, will also suggest many possibilities for the rendering of textures. Smooth, shiny, and wet surfaces are rendered most effectively by the use of extreme contrasts of dark and light, using the white of the paper to simulate the intensity of the highlights.

In working on this problem, you should remember that you are really executing three distinct types of drawings. The outer shell has a special shape, surface, and texture, while the cross-section has an analytical character and involves another variety of textures. The seed introduces a change of scale as well as another textural dimension. The arrangement of these three drawings on one page, as one image, and the suggestion that they are related, that they represent different revelations of each other, must be given some carefully researched attention. Scale is one of the major difficulties. Chances are that the seed will have to be greatly enlarged. In most cases, the cross-section should retain the scale of the exterior rendering. It may, however, work equally well reduced, providing the possibility of establishing a progression between the large outer form, the cross-section, and the seed. If you do not consider these possibilities, the three parts of your drawing may lose the feeling that they belong together and consequently lose their sense of purpose. Your page must represent a balance of open spaces, form, lights, and darks. The design of the page is essential to the impact and visual effectiveness of your drawing.

A word about drawing the seed. Seeds may be oval, elongated, round, flat, or bean-shaped, but they are seldom regular. The outer shell may contain outgrowths and protuberances, such as the hairs on the milkweed, or it may show a small scar marking the place of its attachment to the container, like the bean seed. These scars and markings contribute in no small way to the distinctive character of each seed. The observation of such distinctions is a prime characteristic of an exciting drawing.

Seeds and Fruit Seeds are fertilized ovules, and inside the seed is an embryo. Sometimes the embryo is enclosed in an endosperm, a substance rich in food which nourishes

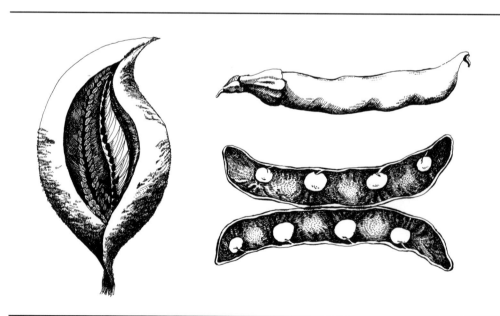

the embryo once germination occurs. Corn, dates, and coconuts have seeds in which the embryo is small and the endosperm large. The meat of the coconut is endosperm. In some seeds, there is no endosperm; in other seeds the embryo absorbs it in advance of germination.

Some fruits await the right time and the right conditions for germination. Some dry fruits, such as follicles, legumes, and capsules, open at maturity. The milkweed follicle opens on one side only. The pea legume opens on two sides. The iris capsule opens in several directions at once.

Achenes, grains, samaras, and nuts are dry fruits that do not open at maturity. In achenes, produced by the buttercup, dandelion, and sunflower, the seed nearly fills the cavity of the fruit. Wheat, rye, oats, and barley are grains in which the seed and the fruit are one. The seed becomes fused to the outer covering.

Oaks, chestnuts, hickories, and pecans produce nuts which usually consist of only one seed. The horse chestnut, Brazil nut, and peanut are not nuts, but seeds from a capsule. The almond is the seed of a fleshy fruit in the same category as an olive and known as a drupe.

The peanut, whose two halves represent the two cotyledons, or primary leaves of a plant, is a legume, like the pea, except that it does not open at maturity. It is also unusual. After the flowers die, the fruit appears as a small, stalk-like structure that contains one to three tiny, immature seeds at its tip. Within a few days, the tip extends and bends, producing a peg that continues to grow downwards until it touches the ground and penetrates the soil up to several inches. The tip swells and matures and is able to absorb calcium and other nourishment directly from the soil as if it were a root. The fruit capsule thus formed is called a peanut.

What we call a Brazil nut are the 12 to 20 seeds produced by a capsule up to six inches in diameter and weighing from two to four pounds. When the fruit is ripe a lid falls off the capsule, forming an opening through which the seedlings can grow. However the opening is too narrow to allow the seeds to fall out and, after three months of germination, the plants compete so fiercely for light and space that only a few survive.

These are but a few of the many varieties of fruits produced by flowering plants. Their forms vary greatly and their methods of releasing seeds are wondrous and complex — challenges to the imagination of a designer.

Figure 17. *Milkweed follicle, pea legume, and iris capsule, showing one-sided, two-sided, and three-sided methods of opening.*

7 Seed-Pod Designs

By one definition, to design means "to form a plan or to draw a sketch; to invent and dispose of the forms, parts, or details of something according to a plan." By this definition, nature is *the* original designer, the maker of the master plan of master plans, of sub-plans, and of multiple plans. Nature proliferates the forms that fulfill its plans, and with unmatchable magic and absolute precision causes them to harmonize, balance, relate, and contrast with each other. While the subtlety of nature's forms is beyond the reach of her human creations, the idea and the example are readily available to the artist.

Working in two dimensions, artists are concerned with a very few relationships. In the physical sense, their forms need not function. Their concern is with relationships of size, of color, of form, of position, and of means. Lines, points, tones, materials, and surfaces are their means. Within these limitations, successful artists can imitate nature's forms, and they can suggest and invent illusions of great complexity.

To make a design based on the forms revealed in a seed-pod means, first of all, to understand the relationships and functions of these forms. Then it means to render them, making use of the most disciplined methods available, and elaborating according to plan. This problem demands a drawing that is not representational, as the last one was, but that abstracts, and to some extent simplifies, relationships. If it were simple enough it could be called an image. If it clearly represented the idea of a fruit it could be classified as a symbol. But a design is more general than an image and a symbol. It allows you a wide choice in selecting and emphasizing any relationships you choose.

When an artist renders from nature he must concentrate, before starting, on all the complex visual impressions before him, but when he makes a design he must have already seen and he must take the time to reflect on his observations. He must select and isolate certain relationships. He may simplify and he may exaggerate. He must reduce something complex to something quickly perceived, something which contains the essence or the essentials of certain relationships. A good design, like a good drawing, should describe something, or seem to be describing something, or lend itself to interpretation as a description of several things. He must invent forms and then express their relationships with maximum graphic impact.

Seed containers provide a variety of relationships capable of interpretation through design. They have an outer and an inner structure, and they contain

Pea-Pod Design, *ink on paper. A subtle design based on the arrangement of peas in a pod.*

Divisions, *ink on paper. Geometric design based on the cross-sectional view of several kinds of fruit. The arrows, which serve as seed dividers, also suggest the idea of growth.*

subdivisions in simple or combined arrangements. They open in various ways. They can be cut and examined in a variety of cross-sections. They have hard or soft shells, thick or thin cores, large or narrow spaces. As structures they can be related to buildings, ships, or space conveyors. They have subdivisions, inner and outer units. They are enclosures. They are carriers of units, or life-giving forms, of symbolic creatures. They dispose their passengers in circles, in lines, in files, staggered, piled together, spread out, or isolated and alone.

When we discussed the pattern traced by the veins of a leaf, we spoke of an exciting design. The lines of the veins are strong and bold. Their thickness varies with irresistible consistency. They subdivide equal spaces with absolute precision, yet they contain subtle changes of direction and delicate irregularities. To be effective, a design must convey this sense of planned relationships. It must reveal, with simplicity and boldness, the essence of an unfamiliar place. Like a map, it should unfold the contours of an unknown land.

The Problem Take the fruit you selected in the previous problem or another if you do not find yours suitable, and analyze its parts and functions by cutting it in various sections. Then, using either the grouping of seeds, the outer form of the shell, or the inner structure of the container, or preferably all of the parts in their relationship to each other, make a bold and strong design expressing the relationships which you have observed — or which you wish to emphasize — between parts, forms, or structures. You may use pen, brush, or pencil for this problem. The idea is to make a strong and exciting visual design. It may be entirely flat and two-dimensional, but it must express some relationship between parts which corresponds to the reality in nature.

The Design A clear and bold design will normally have clean and distinct edges, a definite outline, and precise definition in its details. An exciting design will also try to make the most of contrast: contrast between light and dark, between positive and negative spaces, between masses and linear forms, between curves and straight lines. This is not to suggest that you should invent forms, but that in examining your subject you should look for all the possible ways of emphasizing the contrasts that do exist.

In dealing with black and white contrasts, or with positive and negative forms, you should consider the movements of the observing eye. It should be possible for the eye to focus its attention on the black shapes and to move through the composition, from black to black, seeing relationships of size, direction, and interval, with the white shapes acting as a background for this movement. Similarly, it should be possible for the eye to focus on the white shapes and to follow their interactions against black. Intense competition for dominance between white and black shapes and between positive and negative spaces can create great visual excitement. To cause the eye to follow the whites or the blacks only long enough to question which has the more dominant importance can create a very desirable tension in the viewer.

It may be worth considering that black and white do not have a similar value as color, nor do they have a similar weight as mass. In addition, the space surrounding the design can significantly affect the impact of the design, if it is white or if it is black.

The relative weight of black and white is particularly evident in relation to three-dimensional forms. If a lamp post is painted black, it will appear much thinner and lighter than one painted white. A ballet dancer wearing white tights appears to have legs of much greater substance and thickness than a dancer wearing black. These effects can be heightened by lighting, background colors, and other factors, just as a drawing is affected by the character of the paper on which it appears.

Enclosure, *charcoal on paper. Subtle changes of tone give this design a strong three-dimensional quality. The image of an enclosure with its captive seeds is suggested with great power.*

Two Seeds, *pencil on paper. The network of lines enclosing two spheres suggest both the outer shell of a seed-container and the subdivisions of the core.*

To make an exciting design you should seek out contrasts of form, of large and small, of smooth and angular, of light and dark. Circles, squares, and triangles are among the most compelling ready-made abstract forms and should be used to advantage. In addition, contrasts of line, tone, and direction can give the impression of variety when forms are limited. Lines in contrasting directions, circles or squares in opposing tones, triangles at variable angles, all offer opportunities for variation and contrast.

Repetition can also be a useful device for exciting the eye, particularly when the repeated form is compelling in itself, or if it changes position very slightly, or if slight changes of tone or size occur in sequence.

Of course, over and above the obvious devices for exciting the eye, the significance of the design is of first importance. If seeds are arranged in a particular manner your drawing must reflect the truth. You should concern yourself with the drawing only after you have established the relationships that exist. Then you should analyze the general, visual impact of the forms, and you should consider those elements which give clarity to the expression of function and purpose. The seeds may be small and numerous, and the container, by comparison, a giant shell. On the other hand, the seeds might be large and placed in regular and precise positions. Or they might be medium-sized and arranged in a disorderly fashion, with regularity provided only by the structure of the shell. Whatever the nature of your seed container, your design must reflect it, explain it, simplify it, and possibly caricature it. Besides explaining itself, your design should be bold and strong and visually interesting. It should sit very much in the center of your paper, beckoning the viewer hypnotically. Hopefully, having been hypnotized, the viewer will become excited, will follow the details of your design, and will discover with surprise that he has learned something about the organization of forms in nature.

Seeds and Flowers

The millions of tiny spores produced by ferns and mosses are adaptations of the reproduction of seaweeds, but seeds represent the most unique achievement in the evolution of land plants. Seeds carry oils, starches, and proteins, stored with a mass of cells, which allows them to develop leaves and roots in any favorable place, even without water.

Ferns and mosses establish themselves where rocks, trunks, branches, mounds of earth, and small cavities allow them to enter and grow. But recent, flowering trees, like the birch and the thistledown, have begun to challenge the special place of spores with tiny, wind-blown seeds. The very fine seeds of orchids will attach even to the bark of trees, and the seeds of alder can drift, unharmed, on the water.

While seaweeds adapted to the land and developed roots and stems and leaves, invertebrate and vertebrate sea creatures transformed themselves into the insects and reptiles and mammals of the earth. They ate leaves, took shelter under branches, dug among roots, and became the mobile counterpart and, ultimately, the essential collaborators in the development of plants. They ate the seeds and they pollinated the flowers.

The flower is an adaptation meant to secure the fertilization of embryonic seeds. With color and scent as an attraction, with nectar as a reward, flowers have lured beetles and bees, butterflies and moths, birds and flies and bats into transferring pollen from male to female parts, from flower to flower, from plant to plant. Through this process, there have developed sexual differentiations of plants, changes in flower structure, variations in fruit, and alteration of seeds. The essential elements of a flower are shown in Figure 18.

The shape of the flower has varied in the course of evolution, has adapted to the availability of pollinating animals, and has tended toward greater refinement and restriction in availability to all insects. Bees clutch and crawl, but not as clumsily as beetles; butterflies hover and flutter, and have long tongues with

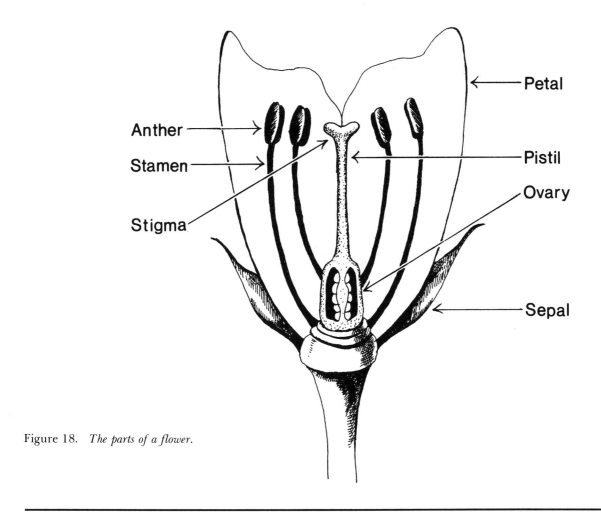

Figure 18. *The parts of a flower.*

Figure 19. *Bees pollinating salvia. In a young flower, pressure on the lower petals brings the pistils into contact with the back of the bee. In the more mature flower, the pistils have lost their spring, and the anthers are brought in contact with the bee instead.*

which to sip nectar. Honeysuckle is the perfect fit for the tongue of a moth. Open, radial flowers, with many pistils and stamens, are typical of the early form of flowers, originally pollinated by birds and later by beetles. Magnolias, poppies, and anemones, which are among the oldest flowers still in existence, are pollinated by beetles, whose fine sense of smell is responsible for the scent of roses.

Birds have little sense of smell and their preferences run to strong, scentless, bright-colored flowers that hold lots of watery nectar. Hummingbirds, honey-eaters, thrips, and parrots are among today's most common bird pollinators in temperate and tropical climates. The flowers of mistletoe, acacia, and hibiscus are pollinated by birds. Carrion, dung, and blue-bottle flies pollinate the tropical fly-flower, which has the appearance and the smell of decaying meat. Bats pollinate calabash, cotton, baobab, and wild banana trees, mostly in Africa and Asia. Bat-pollinated flowers open at dusk, and smell of dead fish and sour milk. Their mouths are wide, and, as one would expect, these flowers hang in clusters, facing downwards.

Attractive petals, scent, and nectar have no meaning to the wind-pollinated flowers, so they tend to be small and inconspicuous. Oak, beech, hornbeam, chestnut, birch, and poplar are wind-pollinated trees. In the early spring, when there are no pollinating insects, and before the new foliage obstructs their flight, wind blows the pollen from dangling male catkins into the cone-shaped, female flowers.

Evolution has led to the production of large, irregular flowers, like the iris and the orchid, which provide entrance for certain insects only, and insure that pollination will take place. The upper and lower lip are formed by special petals so carefully placed in relation to the pistils and stamens that a bee entering the flower cannot avoid being touched on the back by the two anthers of a young flower and by the stigmas of a mature one (Figure 19).

Hive, *pencil on paper. Boxlike divisions suggest the seed pockets of pomegranates and similar fruit, as well as a beehive.*

Grid Network, *ink on paper. This geometric composition is derived from the longitudinal cross-section of cucumbers and squash. It suggests the alternations of open and closed spaces.*

8 Seed - Pod Constructions

All manifestations of nature and all man-made products have form, and all form exists because of a structure, whether it is a form painted on a canvas support or a piece of fabric, a blade of grass held up by water-filled veins, a cloud of moisture supported by the wind, or a vase of molded glass where the form and the structure become one and the same. The source of all these structural principles lies in the forms of nature, and it is to this origin that artists must necessarily turn for instruction.

The varieties of fruit suggest a vast number of possible approaches to structures, enclosures, and groupings, and, in order to make a construction derived from these forms, the first task will be to isolate the general structural characteristics of a particular fruit.

Fruits developed from the need to protect and propagate seeds. Their form has been affected by many factors, including the shape of the flower (which assured the fertilization of the seeds), the realities of developing animal life, soil conditions, climate, geography, and the competition of other types of plants. Their diversity is traceable to a multitude of adaptations over an enormous period of time. Although most of the fruits we know today represent recent adaptations to human cultivation, their function — the propagation of seeds — remains clearly evident and this cannot be ignored in any analysis of their structure.

The form of the shell, the shape of the inner core, and the arrangement of the seeds are the three main structural elements that can be isolated from the analysis of a whole fruit. They may be dealt with separately or considered as an integrated whole.

The shell of a fruit may be soft or hard, swollen or shriveled, continuous or subdivided, tightly enclosed or marked by lines, openings, or segmentations, and these can provide a large variety of suggestions for structural inventions. The inner core is usually complex, with innumerable divisions and subdivisions, and this too can provide a most fertile variety of ideas for the creation of structures. The seed groupings themselves cannot be separated entirely from the structure of the inner core, whether they are held in a pulpy mass as in a banana, lodged in chambers as in an apple, held by a stem and separated as in a pea, or clustered as in a pepper. Nevertheless, in their method of attachment or in their groupings, they can also provide the basis for a structural construction.

Once the structural elements have been selected, then the proper relation-

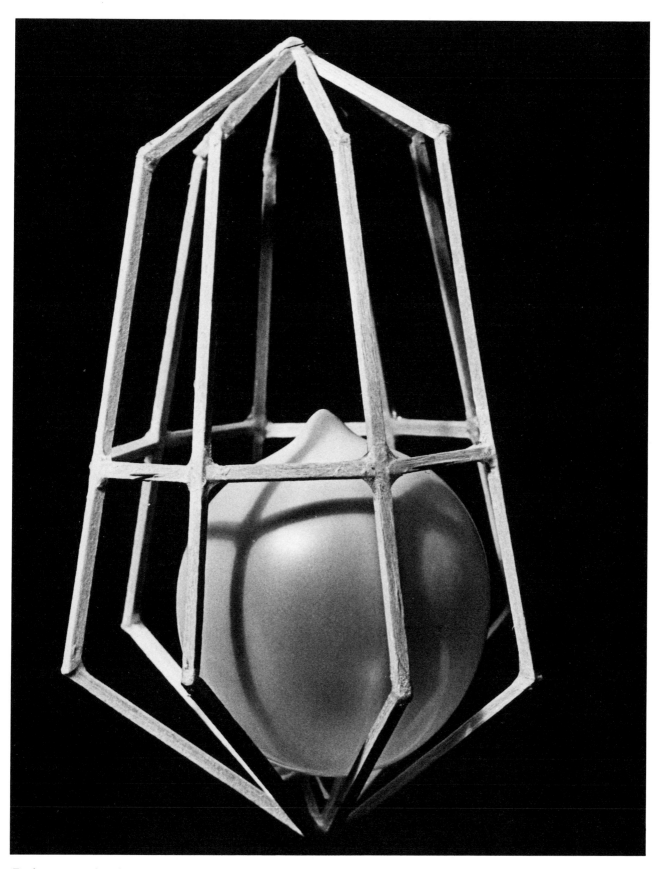

Enclosure, *wood and rubber balloon. The balloon can be blown up until it pushes through every opening in its wooden cage. This "seed" and its container suggest growth. A well-considered solution to the problem.*

ship of the forms, the manner of joining the parts, and the unifying of the structure so it achieves a visual and tactile presence become crucial material problems to be solved. In doing this, however, the intended purpose and function and the general character of the fruit cannot be ignored.

An artist works with ideas and with materials, and significant works of art depend on their successful integration. Without the idea, the purpose, and the generative force, the need is missing. Without the material, the substance and the reality of the expression is absent. An artist should always choose the forms which most closely correspond to his personal feelings and which he can endow with a personal significance. He should also experiment with those materials that please, excite, and stimulate him most.

In dealing with most materials, the artist must perform operations, must work and bend a resisting substance to his will. He must cut, fit, or glue; tear, sew or tie; pour, stretch, or squeeze; burn, melt, or dry a substance in order to give his idea expression. Through these processes his idea is tested, transformed, and, ultimately, solidified into the three-dimensional form. The artist's idea and need must be strong enough to survive this encounter with reality.

The Problem

This problem involves the examination of a seed-container, preferably the one which you have already chosen, drawn, and abstracted as a two-dimensional design. It calls for the selection of at least one of its structural elements from which to make a construction. Any materials may be used and any principle of construction may be followed. However, the construction must bear a direct relationship to the seed-container from which it is derived.

The problem is not to recreate the seed-container, but the idea of the seed-container, or an aspect of it. You may want to concentrate on the seeds — on the way they are attached, grouped, or separated, or on the peculiarities of their shapes. You may want to concentrate on the inner or outer core of the seed-container, or you may simply want to deal with the whole structure, shell, inner core, and seeds. In any case, an imaginative approach is called for.

Seed-containers can be soft, hard, bulbous, solid, hollow, or dry, and their character will affect your construction and the types of materials you use. However, you should feel very free to choose the materials that appeal to you. Whether you use wood, stone, metal, plastic, plaster, cardboard, paper, cloth, clay, or found objects, or any combination of materials, they should make you feel excited, pleased, and creative.

You are encouraged to re-create a structure using full imaginative freedom, whether you deal with enclosures, joinings, or separations. What is involved is the identification, the isolation, and the re-creation of a structural principle. Your construction should, first and foremost, express the truth, however abstractly, of a relationship that exists in nature.

I will discuss a three-dimensional construction because we are not talking of sculpture — that is, the classical concept of sculpture which contemporary attitudes and materials have rendered almost obsolete. Structures, constructions, and fabrications are terms often applied to contemporary works, and they are suitable for this problem.

The Construction

Make a construction that immediately suggests the idea of a container, the idea of a grouping of seeds, or the idea of a seed. Humor, or any other attitude, is entirely appropriate. Esthetically, you should be concerned about the relationship of structural elements, about the balance, harmony, contrast, spacing, and scale of the parts, and about the appropriateness of the materials.

Guard against haphazard arrangements, clusters with no unifying principle, and the casual distribution of seed-like units. Also remember that although a round ball can stand for the symbol of a seed, few seeds are round.

Pea Pod (*Above*), *terrycloth, metal, and plastic. A green terry-cloth enclosure zips open to reveal three green ping-pong balls in this imaginative and very successful derivation of a pea pod.*

Pods (*Left*), *painted cardboard, wire, and wood. Painted gold, these cardboard pods made from egg cartons bend and sway suggestively in the wind.*

Wooden sticks, plastic balls, or wire may well tempt you, and there is nothing wrong with these materials provided you consider all the problems of scale, balance, variety, and significance. On the other hand, there are many other materials available and I would urge you to be imaginative about the materials you select, find, or stumble upon.

First, I would urge you to reexamine your seed-container with a pencil in hand — to draw and to explore all the ideas of relationships that you can extract from it. Ideas about the seeds, the divisions of the container, the bends and suggested folds of the skin can all be of service. Then look for materials that are suggestive. Ordinary found materials are often better than traditional products. Let the material suggest ideas that can serve your purpose.

Once you have started a construction, be prepared to destroy and rebuild it. An idea takes time to develop, and it takes considerable handling to understand the potential of materials and forms.

Your construction should display an appropriate and sensitive use of materials, and the use of color and texture, both in relation to the ideas described and to the abstract balance of the composition. It must be strong enough to hold together under normal conditions. It should not suddenly collapse, sag, bend inappropriately, or become distorted unintentionally through the failure of joints. Use your materials well, both in relation to the larger forms and to the smaller details.

Also consider the appropriate use of three-dimensional form, its relationship to the plane of the ground, its self-contained or environmentally effective aspects. Any of these attitudes are appropriate to three-dimensional form if they fit the intended idea and do not contradict, but reinforce the peculiarities of its character.

Color is an unavoidable aspect of this problem, whether it involves the use of natural materials or neutral tones, and its effect can enhance or reduce the value of your structural form.

It is not essential that the colors you use, if they are applied, be a reflection of reality. They could, in theory, enhance your image without having any realistic significance in themselves. On the other hand, color can be used to suggest or to reinforce the relationship to nature which the materials themselves may lack. This is a delicate matter for you to determine after you have made your construction. However, the value of color, its significance, its symbolic and connotative possibilities, should not be overlooked in solving this problem.

Texture may be a more difficult matter to control than color, since it is a function of materials. However, it may be possible to select materials which, through their contrasting textures, suggest the real properties of a fruit. They may also contradict these real properties, producing a startling or humorous identification. They may, on the other hand, create relationships which are purely abstract, and serve only to enhance the structure or to reinforce the contrast of parts. This problem will have served one of its purposes if it helps you discover some of the properties and uses of materials.

The study of nature is an opportunity to explore materials, colors, textures, and forms. It is an opportunity to discover many structures and principles of construction. In the process, it can serve to uncover imagination, inventiveness, and the clues to creativity.

The Fruit and the Flower

The evolution of the fruit of flowering plants has been the result of so many kinds of adaptation that no direct sequence of development can be established from early times to the present. However, we do know that flowers have evolved from a structure in which the ovary containing the seeds was located at the heart of the flower, to a later stage where, for protection, the ovary was contained beneath the flower itself. Therefore, we can say that an apple, which contains the

Growth, *painted plaster and metal. Bent spoons rise from a plaster base to suggest the growth of plant shoots as they break out of the pod.*

dried remains of the flower at its tip (indicating that it is the product of an inferior ovary), is a more recent fruit than an eggplant, in which the dried remains of the flower are to be found at its base. The scar at the end of a banana indicates the former location of the flower and classifies it, like the apple, as the product of an inferior ovary. The green pepper, like the eggplant, is the product of a superior ovary and of an earlier stage of evolution.

The development of an interior ovary helped to protect the ripening seeds from the premature interest of animals during a period of population explosion of seed-eating animals. For the same reason, many types of fruits and plants developed a prickly armor of thorns. The knobs on a cucumber are the remnants of its former armor of thorns. The needles of the cactus, the hairs of the gooseberry, and the thorns of the rose and the blackberry were all devised for protection against the unwanted interest of hungry animals.

In evolutionary terms, the fruit containing one large seed, such as the acorn, and the pod containing thousands of tiny seeds, such as that produced by the orchid, are recent developments. According to some theories, the early propagation of seed-bearing plants was entirely dependent upon animals. The chestnut that drops of its own weight and sprouts on the forest floor and the seeds of the willow which are borne by the wind are recent forms of evolution designed to avoid the intercession of animals. The berries meant to be eaten by animals have developed a variety of forms. Tomatoes, bananas, and grapes are varieties of berries which have developed seeds small enough to be swallowed without damage to their fertility.

Besides the position of the ovary above or below the flower in the superior or inferior position, the arrangement of the seeds within the fruit reflects the arrangement of the stamens and pistils in the flower. The numbers three and five play particularly important roles in the arrangement of seeds in flowers. The flowers of edible fruit have five petals and five sepals or multiples of five, and, in turn, the seed divisions within the ovary correspond to these groupings. Tomatoes have five main seed clusters. Apple cores contain five pockets of seeds (Figure 20).

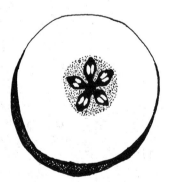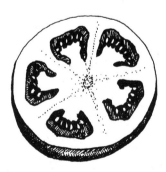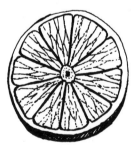

Figure 20. *Cross sections of an apple, a tomato, and a lime, showing seed cluster divisions in five sections and ten sections.*

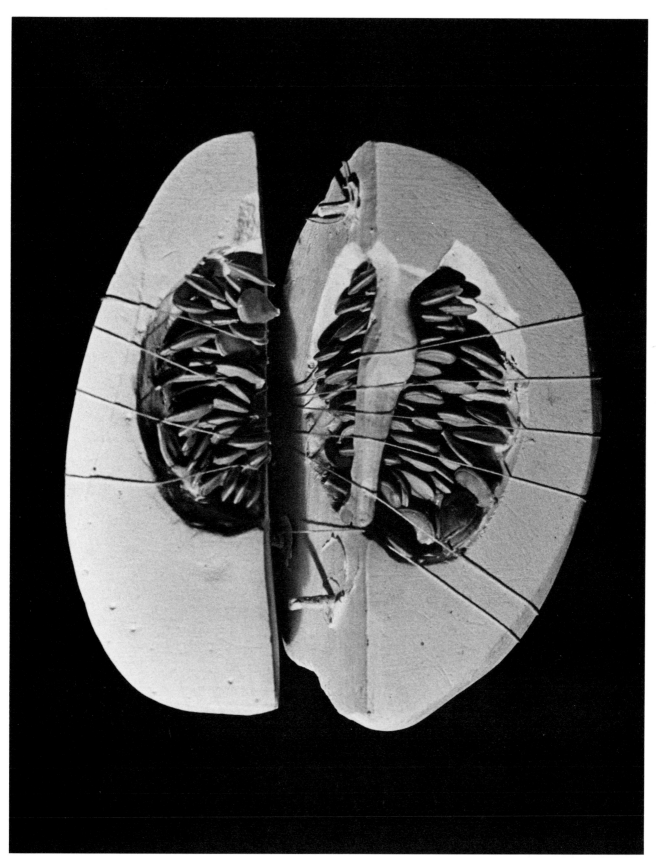

Sectioned Pear, *painted plaster, string, and seeds. Real seeds are glued to a two-part, painted plaster receptacle. The subtle use of color and the mysterious presence of strings strongly suggest the idea of containment.*

Older flowers have many stamens and pistils. Magnolias, roses, and water lilies are all flowers with many stamens and carpels. Irises and tulips are newer flowers with few stamens and carpels. Many flowers have tended to become more complex in shape, divided by sex, and more restrictive in their methods of pollination. The shapes of the orchid and iris, forsaking the radial symmetry of the daisy and other early flowers, are designed to provide alluring passages for pollinating bees. The shapes, in addition, assure fool-proof contact between the animal and the stamens and pistils, eliminating the need for large numbers of these organs.

Although one direction of evolution has been toward simpler flowers and simpler fruit with fewer seeds, there has also been a development toward smaller and more numerous seeds and flower heads composed of many small groupings of individual flowers.

Stems bearing many flowers have helped guarantee both pollination and cross-fertilization. It is possible to trace some of the steps involved in the development of these compound flowering stalks.

As flowers have become smaller, the number of flowers developing from a stem has increased, leading to a branching inflorescence. In order of development, flowers have gone from the single flower head with several lateral branchings; from the panicle to the raceme; from the spike to the corymb; from the umbel to the head of flowers, of which the sunflower is an example (Figure 21).

Compound flowers have given rise to multiple and compound fruits of which the pineapple, consisting of the combined fruit of many joint flowers, is a special example.

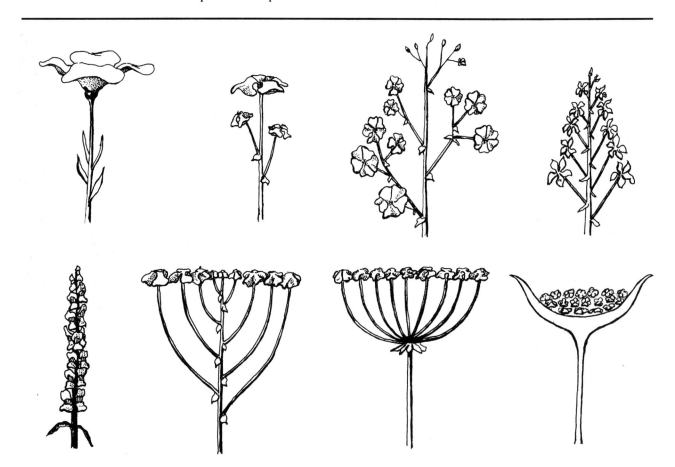

Figure 21. *Developments in the structure of flowers include: a single flower, flower with lateral branchings, panicle, raceme, spike, corymb, umbel, and head of flowers.*

Caged Plant, *wood and macaroni. Dry macaroni fills a well-made miniature cage to suggest the roots and shoots of matured seeds emerging from a pod.*

9 Self-Perpetuating Growth

"The universe keeps its form by being perpetuated in self-resembling shapes."
George Kubler

All forms of life have within them the means of self-renewal. The sun and the planets, the wind and rain, the temperature and the tides all play a role in favoring this process. All the seasons contribute to the continuum of nature. In the temperate zone, summer is a period of fecundity and growth and fall of maturity and preparation. Winter is a time of rest and anticipation, while spring is the visible period of renewal and birth, a period when seeds germinate, trees flower, green shoots pierce the earth, and birds mate and nest.

When mammals produce formed offspring, we call this process birth. When an egg is laid and a chick emerges from the shell, we do not call it birth, although it is new-formed life. When a seed sprouts, we do not call it birth, although it is renewal and the perpetuation of the species. It is clearer, then, to speak of self-perpetuating growth, the process of regeneration through which the earth, as we know it, came into being.

The motive force, the generative idea in nature is the continuity of life. Growth, change, and regeneration are essential parts of this process. The incredible variety of animal and vegetable forms is the result of adaptation between the need for continuity and the realities of other forms of life, of soil and climate, of geology and history, of time and chance. It is only with difficulty that the mind can accept the notion that the variety of life which we know developed from the humble effort of simple cells merely to reproduce their kind. Chance variations, occurring over millions of years through millions of rebirths, and infinitely small adaptive changes produced the life of the sea. In time, the same small changes allowed the fish to crawl on land, the seaweeds to create plants, and the birds to learn to fly.

It would be easier to believe that small stones, seized by the inspiration to change position, developed legs and heads and became turtles; that great boulders became elephants; that the sun's rays, acting like a snake charmer's flute, caused the trees and plants to stand; that the wind, lifting bits of matter, created all the birds, large and small; that the sea, rolling in dark, arched waves, formed all the fishes. I have always more or less believed this. It is my view that earth, air, fire, and water, acting together as a great elemental force, created all of nature and all the forms through which we know it.

The richness of life arose from the fact that birth is the result of couplings of always slightly different units and that nature, like most artists, is incapable of exact duplication. No two eggs, no two tadpoles, no two kittens, no two blades of

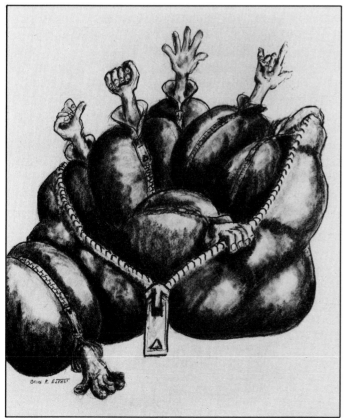
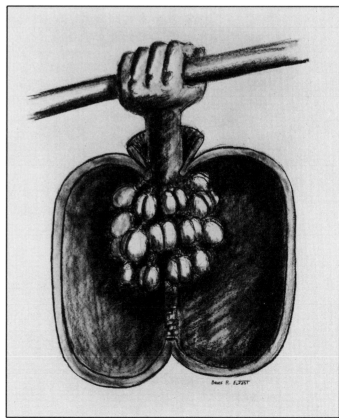

Birth of a Pod, *charcoal on paper. This imaginative and fanciful series graphically presents the idea of self-renewal.*

grass are exactly alike. It is precisely these slight and sometimes infinitesimal differences, repeated again and again over vast periods of time, which have made possible the extraordinary proliferation of forms which constitute the natural world. The means which new forms have adopted to insure their self-perpetuation vary from the divisions of amoeba to the production and growth of seeds, the stages of insect reproduction, and the birth of mammals. However, the common result of these many processes is always the emergence of a form which belongs to the species, which reproduces, with artistic license, all of the essential traits of the parent.

It is the aim of this problem to give visual form to a process of birth which is not necessarily related to a particular species but to all species. It should represent, not the special mechanics of birth, but the broad and general idea which affects all living form, that is, the continuity of life and the self-perpetuation of all species.

The Problem Using pencil, charcoal, crayon, or ink on paper, represent the self-perpetuation of a form in a series of four drawings. The first drawing must show a distinct form and the fourth drawing must show at least the beginnings of one or more similar forms. It is best not to exceed four drawings in order to force a concentrated depiction of the process of self-perpetuation. This process requires no verbal explanation. It must be completely self-explanatory in an entirely graphic way. The four drawings should be of similar size and represent a series which is visually coherent and convincing.

This problem is not intended to involve the depiction of anything resembling the natural processes of birth. It is concerned entirely with the abstract idea of self-perpetuation and with the purely visual representation of a process by which this can occur. The approach must be imaginative and, at the same time, convincing.

The Drawing The drawings in this problem will vary greatly according to the type of images used, the concepts expressed, and stylistic preference. It is a difficult problem, so it is particularly important to feel at ease with your medium.

The last of the four drawings must unmistakably reproduce a form which is the recreation of the first one, although it may, and probably will, differ in size and position and include several versions of the original form. For this reason, clarity in drawing and in the selection of images is particularly important. There must be a visually logical relationship between all the drawings in the series, so the original form appears to be directly responsible for the appearance of the similar forms at the end.

Birth of an Insect, *ink on paper. This brilliant version of self-renewal makes its point with humor and clarity.*

It would be best, in my opinion, to approach this problem by giving your imagination free rein at the beginning, by conjuring up images which appeal to your fancy before making any attempt to give your idea graphic form. Once you have developed an image, it will become important to give it a clear form and to be as simple and direct as possible in rendering it. One reason for this is the necessity of repeating the image several times and in several ways. These versions must be convincing and recognizable, otherwise the clarity of the process being depicted may be confused. This series is, in a way, like a comic strip in which the same characters play a continuing role. They appear in different situations in each cartoon but they must be recognizable.

We know that amoebae and other simple forms of life multiply by subdivision. Plants produce flowers, which produce fruit containing seeds, and these seeds contain within them the embryonic form of the plant. We know that swimming tadpoles emerge from eggs before their transformation into frogs. We know that the larvae of moths become caterpillars and that it is only later that they emerge as flying insects. You should consider these different processes as you prepare your solution to this problem.

In purely visual terms, the process of self-reproduction can be thought of as a form which opens, so that from this opening, another form can be released which will repeat the original or a miniature version of it. A new form can detach itself from the old. It can unfold or unfurl itself, turn itself inside out, revolve, split, shrink, or divide itself in a variety of ways in the process of producing a replica of itself. You should consider your solutions in these terms also.

The forms you use will probably need to be represented as operating in a three-dimensional space, where movement and rotation can occur and be described. For this reason, it is important that the forms you choose remain fairly simple and that the representational style you employ should be well adapted to the depiction of simple and bold three-dimensional forms. If you use shading, make it dramatic. Make your forms very dark in the direction away from the source of illumination, and let the tones fade very swiftly in the light. Use forms with simple contours and be very clear on paper and in your mind about the location and direction of planes on the surface.

Once you have established a form and sequence which appeals to your imagination, you should practice, through small sketches, not only the best way to represent and to place the image in the space available to you, but also the most essential steps required to accomplish the transformation of the form into several replicas of itself. It is likely that you will imagine more stages of development than the four drawings allow. It will require some effort and practice to

Birth of a Sphere, *ink and charcoal on paper. A happy vision of oral birth, these strong images unmistakably suggest the idea of self-perpetuation.*

Birth of a Frame, *charcoal and chalk on gray paper. This unexpected series of images solve the problem with subtlety.*

reduce an extended sequence to its two most essential steps. You should, in this problem as in so many others, consider it essential to make sketches and prepare roughs, and to give yourself the opportunity to change ideas before proceeding to the final drawing.

A form exists (drawing 1), an event occurs within the form (drawing 2), new forms emerge (drawing 3), and the clear outlines of new forms are made visible (drawing 4). It is this sequence which your drawings must bring to life.

The process by which a form, existing in time and space, is transported and reproduced on a flat surface through the intercession of a pencil and the skill and brain of an artist is, in itself, a special form of self-perpetuation. This should provide you with a special insight into this problem.

Sequences The processes by which a form becomes transmuted into other forms have always had a special appeal to artists. Living forms seldom remain unchanged. Life and growth themselves force change. Action and reaction cause changes. Collision and conflict cause changes. Isolation and abandonment cause changes. Sometimes the stages of change can be observed. Some examples of change are given here, not in order to solve this problem, but simply to stimulate thinking about transformation and to provide some visual images which represent, in simple form, changes in appearance.

The oil film shown breaking up in Figure 22 is passing through a process which is common to many liquids, including spider webs. The transformation of a continuous film into separate spherical units is shown passing though four distinct stages.

In the splash which disturbs the surface of a container of milk (Figure 23) derived from a famous set of photographs, the surface goes through a series of convolutions, described succinctly in a series of four drawings. It passes from a flat surface to a series of extending rings.

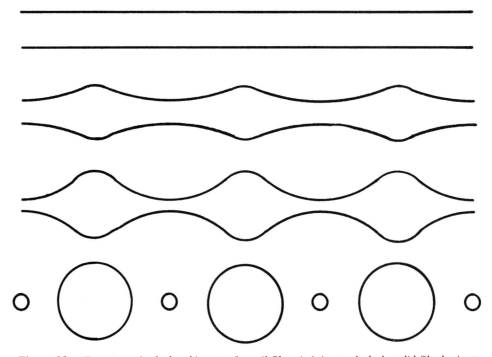

Figure 22. *Four stages in the breaking up of an oil film. As it is stretched, the solid film begins to undulate and finally breaks up in drops.*

1. A cuplike ring emerges from the hollowed surface.

2. It begins to scallop at the edges.

3. Droplets are ejected from the promontories.

4. A central column rises after the outer ring collapses, releasing droplets at the crest.

Figure 23. *Stages in the splash of an object in milk.*

1. Pre-Sumerian: interlocking dwellings are grouped around a central temple.

2. Greece and Babylon: trade routes and the roads of conquering armies lead through the center of towns.

3. Middle Ages: cathedral and monastery villages are spread along pilgrimage routes.

4. 17th and 18th centuries: roads lead out from the seats of power of Popes, Kings, and Emperors.

5. Modern: a democratic grid allows for movement in all directions.

6. Improved modern: living enclaves are organized within a multidirectional grid.

7. Future possibility: enclaves are related to city centers by main roads.

Figures 24 and 25. *The development of cities.*

The development of cities may seem far removed from the phenomena of nature, but the changes involved in their organization, affected by both internal and external forces, represent transformations which contain considerable visual logic (Figures 24, and 25). These sketches are derived from notes taken during a lecture given by the late Sybil Moholy-Nagy, an extraordinarily brilliant woman, while she was preparing a book on cities. They consist mainly of regroupings of lines and circular forms, yet they represent a development which creates a valid sequence. The transformation of one medium by another can be seen in a very graphic way by the simple exercise of placing a drop of ink in water (Figure 26). The ink particles adhere to each other with tenacity and, before dissolving, create graceful arches and demonstrate a clear series of linear transformations.

A drop of ink floated onto a medium more dense than water (Figure 27) will begin to form a less linear pattern and develop forms with a strong three-dimensional quality. Your own experience will undoubtedly provide you with many other examples of transformation and change which can serve as a stimulus to the development of an exciting sequence of drawings representing the continuity of forms.

Figure 26. *Changes in the shape of ink dropped in water: a ring forms; edges begin to sag; the sagging ends prolong; the prolongations descend; arches become elongated and thin.*

Figure 27. *Medusa-like shapes are assumed when a drop of ink is placed in oily liquid.*

10 Rubbings and Textures

Until now we have concerned ourselves primarily with structure and form, but in the appearance of things in nature texture is often the most immediately perceived, revealing, and identifying visual quality. Water and sand, grass and sky, animal and insect all have a distinctive surface quality, a texture, by which we recognize and comprehend them. Shiny, matte, irregular, grainy, striped, fluffed, transparent, reflective, serrated, and smooth are all terms describing textures — the surface appearance and quality of things. No artist can hope to describe the world about him without an understanding of textures and without acquiring a repertory of two-dimensional effects by which he can describe the surfaces and, sometimes, the very character of things.

The effect of texture was evident when rendering the appearance of a seed-container. A pepper is shiny, a banana matte; a melon is coarse and a chestnut hairy. These characteristics are as important as the shape, the form, or the structural details of a fruit. To convey the characteristic appearance of a surface, the artist must learn a special set of technical manipulations.

Every material substance has a physical quality, and most have a distinctive, identifying surface texture. Wood, stone, and metal are readily distinguishable, physical substances. Skin, fur, feathers, hair, shells, sponges, sand, fruit, bark, and leaves all have differing and distinctive textures. Man-made things derived from natural substances have added to the available variety. Cement, wicker, wire mesh, velvet, cotton, wool, plaster, plastic, paper, glass, and rubber are in this category. Many textures closely resemble each other, and an artist familiar with the problem of rendering textures can, starting with a few simple patterns and techniques, obtain any effect he wishes.

Textures are actually patterns that are repeated with varying degrees of regularity. The artist can manipulate these patterns to recreate a wide variety of textural effects. They can be repeated, overlapped, and superimposed. They can be provided with differing values, blemishes, appropriate irregularities.

Some artists are particularly expert at texture-making. Many are partial to special effects. Salvador Dali is especially adept at the rendering of liquid forms and light-reflecting surfaces. In the work of the great portrait painters, such as Velásquez and Sargent, satins, silks, velvet, and lace come to life in a particularly tactile way. Gold and jewelry held a special attraction for Rembrandt. The opulence of oriental rugs and the diffusions of light on a plaster wall are lovingly detailed in the small paintings of Vermeer. Andrew Wyeth is particularly mas-

Safeguard Still Life, *pencil on paper. The combination of direct rubbings and derivative patterns makes an animated still-life rendering.*

terful at the rendering of a variety of textures, with pencil and with paint. His work will repay close study by anyone interested in surface appearances. By the delicate manipulation of a pencil or a brush, he can transform the same generalized, textured surface into an old wooden barn, a house made of bricks, the side of a cow, or a patch of wild flowers.

It is important, however, to distinguish between rendering a texture and texturing a surface. Van Gogh, for instance, textured the surfaces of many of his later paintings. Sometimes this had a descriptive relationship to the objects he painted, sometimes it did not. When wind-blown flowers become a wind-blown sky, a quality of atmosphere is being depicted, but not the actual physical substance of an object.

The irregular application of materials to a specific surface, the uneven distribution of a variety of tones, the seemingly accidental superimposition of dots and lines — all are techniques that can produce a generalized effect of texture. Many artists use these and other methods to produce uneven and suggestive surfaces over which they then begin to impose the desired forms. By reworking certain areas, they are able to refine the specific textural qualities of each. While this process is indirect and slow, it can be very effective. The animated surface suggests approaches to a variety of textures, and these textures, as they are refined, maintain a common character of tone. This is important in balancing values in a drawing and in suggesting a uniform degree of depth and illumination.

The Problem

This problem is in two parts, the first of which involves making rubbings from at least twenty surfaces of different textures. These can be prepared from either natural or man-made materials, preferably both. They may be made with pencil, charcoal, Conté crayon, lithograph stick, grease pencil, or ink. They can be used on tracing paper, rice paper, or any other semi-transparent or sensitive surface. Color is not an aspect of this problem. The rubbings should be no smaller than three inches square, and all twenty should be mounted together on one or two large sheets of heavy paper or cardboard. This will serve as a reference chart of textures for use in the second part of the problem.

The purpose of the second part of this exercise is to give you the opportunity to reverse the rubbing process and to discover the pattern-making techniques that can re-create illusions of texture. It should also help you to observe the differences and the similarities of a variety of patterns and to see their value and effectiveness in making a drawing.

Select from among your drawings a simple still-life composition or a landscape that is not too complicated. If you do not have one, make a drawing of the arrangement of a few simple elements: a bottle, a piece of stone, a tabletop, and a drape will meet the requirements. These objects should have some distinguishing texture or pattern; your drawing should include the rendering of surfaces as well as the outline of shapes. When you have done this (and it is not necessary that this be an elaborate or beautiful drawing), refer to the chart of the rubbings you made in the first part of this exercise and select several patterns that have a logical correspondence to the textures in your drawing. You should now redo the drawing, applying, in a freehand manner, the appropriate patterns derived from the rubbings. You should be able to produce an interesting drawing, enriched by the association of unfamiliar patterns. It may demonstrate the value of certain techniques and resources of which you may not have been aware. It may also help to enliven the general quality of your future drawings.

The Rubbings

A variety of techniques are available for making a rubbing, all involving the direct transfer of the textural qualities of a particular material onto a two-dimensional surface. It is possible to make rubbings with pencil or with ink, on opaque or on transparent paper, on a dry or on a moist surface, by simple or

Landscape, *ink on paper. A fantasy landscape which makes successful use of the large variety of patterns derived from rubbings of many textured surfaces.*

complicated processes. As every elementary student probably knows, if you rub a sheet of paper very hard with a pencil, the texture of the surface lying beneath it will be clearly revealed among the multitude of pencil strokes. The simplest rubbing technique involves no more than the direct application of a pencil to a thin sheet of paper placed over a textured surface. The grain of a block of wood, the irregularity of stone, the serrations of cardboard, the design on a coin will clearly reveal themselves through the use of this basic technique. A really fine rubbing, however, will avoid unnecessary markings, visible pencil strokes, or any other variations in the surface which do not reflect the specific character of the textured material being rubbed. The surface appearance of leaves and tree bark, of fish scales and animal fur, of manhole covers and stone carvings, can be rendered with precision and delicacy through the use of the appropriate techniques of rubbing.

Pencil points, brushes, and other sharp and pointed instruments are not recommended for the execution of sensitive rubbings. The technique is, in effect, a form of positive printing involving the production of a consistent surface from a variety of uneven and protruding parts. For this reason, it is very desirable to use materials that lend themselves to application as flat or broad surfaces. The side of a grease pencil, charcoal stick, or Conté crayon, or the use of a ball of blacking, are among the most effective materials available for producing a sensitive result.

Ink and paint can be applied effectively by the use of cloth tampons and inking pads, on a principle similar to rubber stamps. This provides for a measure of control over wet materials and for even coverage of the surface. However, success depends on considerable experience and expertise, and this technique is not recommended for an initial experience. Ink rubbings are usually made over paper surfaces that have been specially treated with chemicals to reduce porosity. In addition, coatings of wax are used to increase control in applying the ink. A knowledge of these materials, which are too involved for this problem, is essential to this type of printing.

In order to insure success in the making of a sensitive rubbing, it is essential, as is usually the case with a drawing, to make a preliminary rough sketch. A quickly and even crudely executed rubbing can yield essential information on high and low points, on intermediary gradations, on directions, on unexpected irregularities, and can provide suggestions for attaching the paper and for centering the design. The sketch acts as a map to direct the finished copy. Always make one, and refer to it frequently as you make your master copy.

In doing a rubbing, it is important that the surface to be rubbed be securely fastened to the textured material. Slippage will cause a flat, blurred, or distorted image. Good-quality tape and paper wide enough to supply large margins are a necessary part of the equipment required for a successful rubbing. Once the surface is securely in place, you should proceed very slowly, working the material lightly and gently from the center out to the edges. The rubbing should be repeated several times, starting with a very light touch, and not using darker tones until all the prominent surfaces are evident. Referring to the sketch will provide valuable assistance. The area should be reworked, carefully selecting the details requiring the most prominence and attention and allowing for subtle changes of tone to indicate the gradations of relief.

To meet the requirements of this problem, you should examine a variety of surfaces with care, executing many rapid rubbings in order to determine the two-dimensional character of each, so that your final selections will represent as wide a range of textures and patterns as possible. Grainy, linear, irregular, interlocking, open, and regular surfaces should be sought in as many variations of pattern as possible. Your final selection of twenty rubbings should represent as wide a range of surface textures as you can identify.

Still Life, *pencil and charcoal on paper. Although a simple composition, this drawing translates many textures derived from rubbings into usable surface patterns.*

Your exploration of surfaces will have a value in itself. You will be training your powers of observation and you will be increasing your awareness of textural variety. You will also notice the unexpected similarities in the two-dimensional patterns of many contrasting substances.

Fabrics are in a category by themselves; they provide a tremendous variety of patterns simply through the number of combinations possible with weaving techniques. But you should seek out all the possible sources of textures, even including foodstuffs of every kind. Cold hamburgers, bread, cheese, and tea leaves are all legitimate sources for the examination of textures and their two-dimensional effects. So are leaves, grass, pine needles, pine cones, twigs, straw, stone, wood, gravel, and sand.

We are not, of course, dealing with images in this part of the problem, so that the shape of a leaf, the outline of a fish, the limits of a stone are not a concern of this problem. We are dealing with surfaces only, with the peculiar chemistry of textures, so that we can explore the variety of patterns which suggest the visual qualities of physical things.

Rubbings as Art

There has been a considerable interest in recent times in the exhibition of rubbings as a form of art. In part, this has been due to the fact that the sources of these rubbings are often works of art: ancient stone carvings, cast metal forms, bronze plaques and ornaments, already endowed with historical as well as esthetic interest. It has also been due to the legitimate artistic sensibility involved in the identification and the selection of images, and in the variability of techniques and the sensitivity required for their proper execution. There are mediocre rubbings and there are masterful rubbings, and they can be made from rare and fascinating sources which otherwise would not be seen and could not be shared.

Ancient stone carvings from China, bas-reliefs from India, hieroglyphs from Egypt, and tombstone inscriptions from New England have all become accessible through the exhibition of rubbings executed by masterful and sensitive craftsmen.

The art of rubbing, like so much of the artistic heritage of the West, had its origins in China, where it served as a means of reproduction and communication before the advent of other forms of printing. Instructions, decrees, and proclamations were often carved in wood or stone or clay, and the images transferred by rubbing into sensitive fabrics or primitive papers for wide distribution. The technique was also used to produce mementos of rare carvings, to preserve ancient inscriptions, to propagate valuable doctrines, and to make inaccessible materials available in relative quantity and in easily transportable form for shipment to distant places.

The Chinese custom spread to Japan, to India, and then to other parts of the world. Rubbings were a learning tool in Egypt, and have since been essential to the work of historians and archeologists. They have been used for many centuries for purely artistic purposes, as in the leaf and fish prints of the Japanese. They have been used by amateurs of ancient armor, by devotees of brass plaques and ornaments, and by enthusiasts of ancient tombstone carvings. Geologists and zoologists have found them valuable in identifying fossil forms and collectors of art have responded to their interest, variety, and artistic value. Galleries now sell and display rubbings along with other kinds of prints and drawings. Museums exhibit them. The public buys them. They have established their legitimacy in the contemporary art market.

Landscape and Textures, *pencil and charcoal on paper. This beautifully executed landscape makes effective use of all the textural patterns derived from the rubbings shown below.*

11 Fish Prints

*"Thousands have lived
without love, not one with-
out water."*
W. H. Auden

There are more fish in the sea than there are animals on land — more species
and more varieties — swimming, wriggling, crawling, floating in a fantastic vari-
ety of habitats, from polar regions to high tropics, in stagnant pools and coral
reefs and in the mid-depths of the sea, where there is no bottom, no shore, no
surface. Some fly and some walk on land, some are blind and without color,
some are luminous, some hibernate in mud, some are small as insects, others as
large as dinosaurs. Of all the earth's vertebrate creatures, they are the oldest.
After millions of years of evolution, a few crawled out of the water and adapted
to life on land, filled their lungs with air, and became us.

Fish have assumed an extraordinary variety of shapes, sizes, colors, eating
habits, and behavior patterns. There are yellow, red, green, blue, and violet fish,
and fish that can change color. There are fish with teeth, like the carp, which
really chew their food, and there are fish with suckers, with grinders, and with-
out teeth. There are fish who can crush coral and hard-shell mollusks, like the
parrot fish, the eagle ray, and some types of sharks — although sharks are con-
sidered rather indiscriminate eaters and have been known to swallow kerosene
cans and bicycles.

There are vegetarian fish that eat plankton and seaweed, fish that eat frogs
and ducks, and fish that eat insects, although the majority of fish eat
fish — though seldom, except for sharks, do they eat other members of their
own species.

Skates and rays are really sharks which, from lying on the bottom, have
become flattened. They move by undulating their side fins. They also undulate
their bodies so they seem to fly through the water. Their tails are generally
shriveled and have no locomotive power.

The sideways flattening of the flounder takes place as the young fish grows.
As this happens, its two eyes move until they are both on the same side of its
head. The flounder lies on the left and its two eyes move to the right side. The
fluke lies on its right side and its two eyes, therefore, move to the left. They are
not called Picasso fish, however, because there is a Picasso fish covered with
bright stripes and with two normal eyes.

The anglerfish has been flattened from above and rarely moves. It angles
for prey with its own line and bait attached to a rod growing from the top of its
head. The globefish, which is not very wide, can take in water in an emergency
and swell into a perfect sphere with sharp projections like a porcupine.

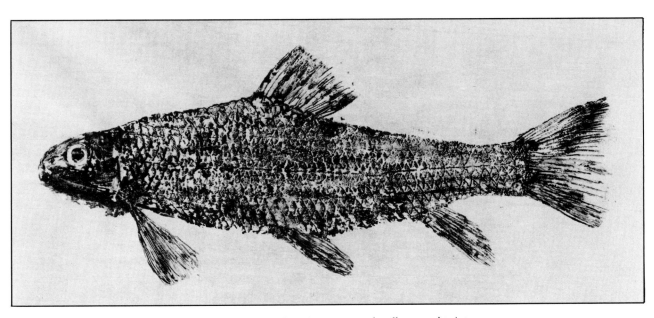

Fish Print, *ink on paper. Every part of a fish is revealed in this strong and well-executed print.*

Fish Print, *ink on paper. Although blurred, the combination of precise detail and generalized areas of darkness give this print a strong sense of animation. It demonstrates the powerful visual effect of textured surfaces.*

The reproductive habits of fish are varied. Most fish lay eggs, but some hatch them inside their bodies and, like mammals, release little fry that are ready to swim. The molly is one, the shark another. Seahorse eggs are carried in a pouch by the male until they hatch. The tilapia's eggs are carried in the mouth of the male until the young are grown and ready to fend for themselves. This takes as long as thirteen days, during which time the parent cannot eat or chew. The female bitterling deposits her eggs in the shells of living mussels to hatch, while the mussel embryos attach themselves to the gills of adult fish, where they are nourished like parasites.

Eels lay eggs in the ocean, in floating islands of seaweed. The Sargasso Sea, in the Atlantic, is one of the five seaweed islands known to exist. After the eggs are hatched, young eels must find their way, still undeveloped, to some fresh water inlet where they can live and grow. When they are five years old, the same age as spawning salmon, they must find their way once more to the Sargasso Sea to lay their eggs and to die. Since the adult eels are no longer able to live in salt water, only the young survive to begin the cycle again. Salmon reverse the process and return to the river source where they were born to lay their eggs and die. They, too, follow a five-year cycle and, when you consider the number of mysteries in nature which involve the number five, like the five petals in the flower of a fruit tree, it becomes clear that the relation of magic and numbers has more than a casual basis.

One thing that nearly all fish have in common is a set of silvery scales, which provides them with a flexible suit of armor. The color of fish is in their skins and is usually seen only when they are in the water. The scales are transparent and silvery when the fish are out of the water. Many fish change color according to their reactions, but this is not visible in their scales.

If you live in a city that has a special fish market, you should pay it a visit in the early morning hours. A fish market at about 6 a.m. is a sight to behold: in giant sheds, row upon row of fish stretched out on blocks of ice that shimmer in the light of orange fires burning in barrels. No set of diamonds in a velvet box can match the glitter of ice and fish scales as they reflect the cold blue tone of the emerging dawn, the orange lights, and the great black shadows of the sheds.

Fish are visually exciting and, besides their shape, it is their scales, acting like thousands of tiny mirrors, that account for a major part of their excitement. These tiny mirrors are set at different angles and represent variable planes that constitute a texture. This texture, while regular, has a number of variations and, like the different lines in the veins of a leaf and the variations in the bones of a fish, express a rhythm — a repetition and a pattern in which each particular piece is not quite the same as any other. Thanks to the active texture of its scales, the image of a fish can effectively be reproduced even when the silvery quality is lost. And there is no better way to realize this than to make a print directly from the fish, whose irregular surface accepts ink and transmits its image.

In this problem, you need do no drawing. You have only to perform a largely mechanical task. In the result, you will notice the extraordinary descriptive power of textures, and you will see how a surface, when it is properly selected and appropriate, can perform all the tasks of description.

The Problem Make a print directly from a fish. Choose a fish whose shape and texture excites you. You should first look at fish in a market or store, to see how richly suggestive their appearance can be. You should strive to make a print that is delicate and sensitive and as exact as possible. The beauty of a print is that you can make several versions, so try a variety of approaches. You should strive, however, to make at least one black and white print that is as accurate and as subtle as you can possibly make it.

Shrimp Print, *ink on rice paper. This print reveals a sense of the movement and essential structure of shrimp.*

Turtle Print, *ink on paper. This view of a turtle reveals the subtle divisions and markings of its shell.*

The Print In Japan, fish prints are a particular and well-established art form known as *Gyotaku*. There are many possible approaches, however, and if you become involved in this problem, you will undoubtedly discover most of them. I will limit my discussion to describing a direct and simple procedure for making a print from a fish.

To begin with, the fish you buy from a store has to be cleaned. The internal organs are squashy and after a while ill-smelling, so the first task is to make a small incision near the lower middle of the fish and to remove the organs. If you are squeamish, the man at the market will probably do this for you, but be sure to explain the need to keep the incision small. Although you need only half the fish for the sake of your print, half a fish will not do. Without its bone structure, the shape of the fish will be lost. Without the fins, a lot of the character will be lost. After disembowling, the fish should be washed. Fish scales are covered with a slimy, mucuous substance, which lubricates the body and functions as an antiseptic to keep fungi and bacteria from adhering to it. However, this slime will interfere with the accuracy of your print, so the fish should be washed off with soap or a detergent. Before you begin your print, close the openings through which internal liquids can drain out. Stuff absorbent cotton or tissue in the mouth, the gill openings above the pectoral fins, the anal vent, and also into the incision you have made. Then, when you press on the fish, liquids will not extrude to spoil the print.

If the fish you have selected is very flat, you may be able to make the print by laying it on paper on a table. If it is a fat or rounded fish, you may have to keep it from moving or rolling by stabilizing the underside with torn paper, sand, or clay. Sand is favored by the Japanese masters. Once the fish is in a level position, spread out the fins and the tail. On many fish, the fins are collapsible as well as spreadable. In some fish, as we have discussed, the fins have recessed grooves into which they can be folded. Your print will gain excitement from the effect of

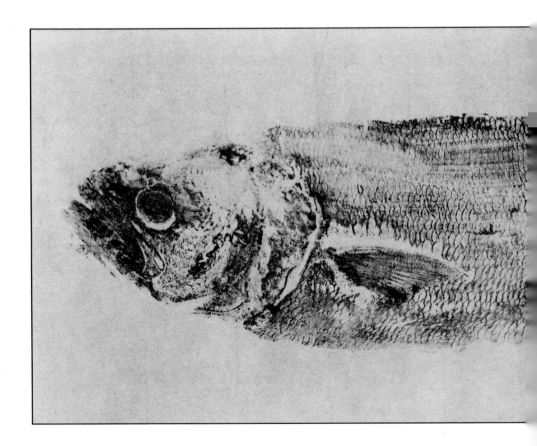

the fins, so they should be spread out in as full a position as possible. When this is done you are ready to print.

A test printing should be made first. For this, some diluted watercolor may be best. Color will help you see the effect more clearly if the material you are applying is thin. You should start off with a dilute substance so as not to clog the recesses around the scales and other places. From this first print, you will be able to judge if the fish is level and steady. You will get a feeling for the form and understand the proper technique of rubbing and how to hold the paper.

Just as in any print, the quality of the paper you use will affect the result. The paper should be sufficiently absorbent to accept the most subtle effects of the ink, but not so absorbent that it will blur the edges or allow lines to run into each other. Newsprint or newspapers can be used to make the test printing. This paper is very effective, but it turns yellow very quickly and eventually begins to disintegrate.

The most desirable and effective paper for a fish print is Japanese rice paper, which has the right degree of absorbency, will last, provides the strongest possible white contrast to the black ink, and which, in addition, has a variety of interesting textures that are subtle enough not to interfere with the print. Because good rice paper is not cheap, make several good test printings with some other material first, to become familiar with the shape of the fish, with the reaction of the ink, and with the proper method of rubbing the paper.

Whether you use ink, tempera, or watercolor, it is best placed on the fish with a brush. The direction in which you brush the ink will affect your print since the roof-tile arrangement of the scales will tend to hold an excess of ink at the joints (Figure 28).

Once you are ready for the first real printing, your ink should be more concentrated, and you should be certain that it is established on the head and fins as well as on the body. Put the paper down with great care. The best method

Figure 28. *The overlapping arrangement of fish scales, reminiscent of a tile roof.*

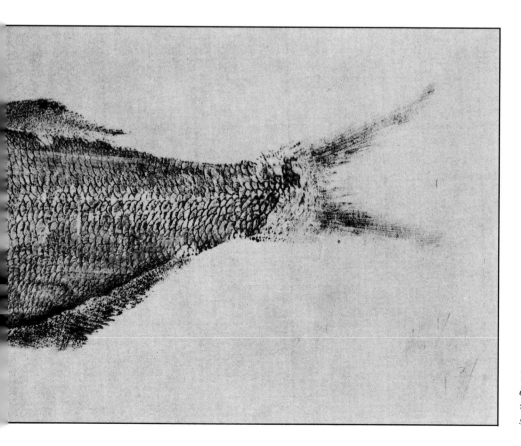

Fish Print, *ink on paper. Executed in light tones, this print reveals the intricate pattern of fish scales with great clarity.*

of obtaining a true print is to rub with your hands and your fingers to insure an even and thorough contact with the entire surface.

As you practice you will discover ways in which you can manipulate effects. For example, one method of proceeding is to apply a dilute amount of ink over the entire body surface and then to apply the more concentrated ink on some parts only, such as the fins, or around the eyes and gills. You can also control gradations of tone along the length of the body.

Once you have produced a satisfying black and white print, you may want to experiment with color. You can obtain striking effects by simply using colored paper and contrasting or matching the color of the ink selected. It is also possible, and fun, to use every color in the palette.

My hope is that, once you have made this print, you will be impressed with the extraordinary visual power of textural effects. Every artist should have this experience.

Fins and Scales Most fishes have two sets of paired fins — the pectorals, just behind the gills on the side of the head, and the pelvics, usually located farther back. Along the mid-line on the back is the dorsal fin, which may be subdivided into a spiny and a soft part. Along the underside, behind the vent, is the anal fin. At the very back is the tail, also called the caudal fin.

All the fins are movable and are worked by muscles in the fish's body. The dorsals and pectorals work together to provide stability. The dorsal fins, standing straight up, keep the fish vertical. The pectorals, reaching out sideways, are used for turning as well as for balancing. The pelvic fins provide stability and lift, like the tail wings of an airplane. The tail fin is used to steer and to propel.

In fast-moving fishes, the dorsal and anal fins fold flat for swimming, and in some species even retract into grooves so they lie flush with the body.

Fins actually vary greatly in placement and size. Among bottom-dwelling fish the paired fins are closer together near the front, and the pelvics are shifted forward, ahead of the pectorals and directly below the jaw. They are used to prop the head and gills above the bottom. In eels, the pelvic fins have disappeared. In the bottom-living searobin, the pectoral fins have become disconnected rays that function like the legs of an insect. The lionfish has fins that are long and feathery, and serve chiefly as camouflage; they match the appearance of the coral growths among which it lives.

The wings of flying fish are adaptations of the pectoral fins. The movements of the frogfish are the result of development of powerful pectoral fins, which permit it to jump and to hop.

Fish can see, distinguish colors, hear, respond to touch, and have an exceptionally fine sense of smell. They also have a sense we do not have, which guides them in schools and which permits them to make extremely rapid movements without being able to see. This sixth sense is located in a series of nerve centers that follow a line running from the gills to the tail. These nerves, which are sometimes clearly visible as a distinguishing line running the length of the fish's body, make fish sensitive to the flow and movement of currents and to minute changes of temperature.

Scales vary in size from microscopic on eels to six inches on an Indian river fish called the maliseer. Only a few fish, like the lamprey, have no scales. The seahorse and pipefish have rows of connected bony plates in place of scales.

Scales grow as the fish grows, and they grow faster in summer than in winter so that, as in trees, they form rings, narrower and wider, by which their age can be told. There are four general types of scales (Figure 29). The most common are the ctenoid and the cycloid. The ctenoid is more rounded and has sharp teeth on the ends. Herring, salmon, bass, and other bony fishes all have one or the other of these types of scales.

Placoid

Ganoid

Ctenoid

Cycloid

Figure 29. *Types of fish scales.*

Fish Print, *ink on paper. Although the pattern of scales is blurred, the subtle delineation of the head and fins against a dark ground makes a powerful image.*

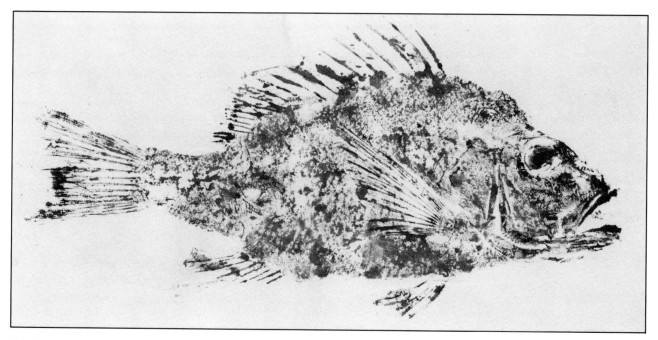

Fish Print, *watercolor on paper. Despite a lack of precise detail, the essential character of a fish is strongly conveyed in this print.*

12 Transferred Textures

Growth, change, and movement create patterns, and as they work through a medium they create textures. Wind ripples water. Water pushes rocks. Sand shifts. Water freezes and expands. Ice cracks. Rocks crush.

Gigantic movements of heat and lava, melting glaciers, heaving earth, and scattering rocks have formed the deserts, mountains, seas, and plains we recognize as the landscape of the earth. Within this landscape, the effects of drought and heat, of melting ice, of rain and erosion, of wind and storm are visible everywhere.

The surface of our planet owes its variety to the great geological upheavals the earth has passed through in its long history. They have created the varieties of landscape, of seas and streams, of the plains and mountains in which we live.

On an infinitely diminished scale, the creations of art have much in common with the processes by which nature creates her forms. Through art, the world appears transformed, transmuted, and metamorphosed. With a few smudges of charcoal, crayon, or paint, the surface of a piece of paper can be made to yield a face, cloud formations, awesome depths, mysterious protuberances, whirlpools, and cataclysmic upheavals. Illusions of form, depth, light, shade, and texture are fabricated by the stroke of a brush, pencil, or pen so that the practice of art seems to involve an element of black magic and spells. The production of art can sometimes be as mysterious as the process of creation itself.

Texture is often the identifying clue to a substance, an object, or a living form, and, when we made rubbings of a surface we discovered the pattern of lines which translates a texture into two-dimensional form. A rubbing reveals the infinite variations simple drawing instruments are capable of producing. It is a lesson in the variety of riches available in ordinary and even familiar materials, in tree trunks and fabrics, wood grain and cardboard, sponges and corks. By examining rubbings and comparing their effects, one can observe unexpected analogies between dried-leaf patterns and mountains, sand paper and stucco walls, washcloth fabric and rough-cut fields, wood grain and the contours of ploughed land. There are drawings by Vincent Van Gogh and Andrew Wyeth in which landscape elements seem to be entirely suggested by variations of pattern-making. In art as in nature, forms often establish their identity by relationship so that even the sky, in some Van Gogh drawings, can be represented by groupings of dots alone.

There is probably no more demanding test of an artist's mastery of textures

Birds, *pencil on paper. It takes a minute
to realize that one of these birds has
exchanged its feathers for a structure of bent
metal plates in this sensitive drawing.*

than the deliberate application of an inappropriate texture to a properly rendered form. It is a favorite trick of the Surrealist painters.

Salvador Dali has performed many a conjuring trick with techniques — distorting scale and perspective, combining forms, bending and twisting unlikely materials, and rendering their surfaces with extraordinary fidelity. He is a master from whom much can be learned. However, for our purposes, he has tended to act too respectfully toward the texture of reality.

In relation to this problem, the work of the Belgian Surrealist painter, René Magritte, is particularly relevant. Although he is a very sophisticated painter, there is a quality about his work that is more often associated with primitive artists. I would call this a sense of the joy of discovery, an excitement in simple things, an attitude visible in his work which gives one the feeling that he can hardly keep from saying, "Look at what I have done!" He paints apples with a lushness, a roundness, a smoothness that outdoes reality; meticulously transparent combs; smokeable pipes; cheap chairs with precisely fitted joints; worn shoes molded to a specifically suggested foot. He paints with an attitude that suggests that he has discovered how to paint something that no one has ever painted before. Perhaps it is for this reason, out of childlike pleasure or the need to share a discovery, that he has also turned many things upside down. He has painted a stone bird flying over a beach of rocks, a burning metal tuba, a sky made of wall paper, fabric made of grass, and a group of people turned to lava.

The tricks of Magritte are used in the service of interesting ideas and they also work within balanced compositions. They look easy, but they require an absolute sureness of means and the mastery of many technical devices. His work will repay careful study in the context of this problem. If you can approach the exercise with some of Magritte's spirit of discovery and joy, you will succeed very well indeed.

The Problem Select an object of distinctive texture and render it with precision and care. The surface quality should be reproduced with all the technical ability you are capable of. You may use ink, pencil, or charcoal and any paper or cardboard with good surface quality. Place your first rendering on the page so there is also room for a second version of the same object, rendered in an entirely different texture. This will be an invention, and the real and the imaginary textures should present an unexpected and, if possible startling, contrast. The two drawings should be placed in sufficient proximity for comparison, and both the real and the invented texture should appear to be a natural quality of the object you depict. It should come as a surprise, almost require a "double-take," to notice that the invented texture is not appropriate to the object depicted. In short, both textures must be convincing and both drawings must convey the impression of reality.

The Rendering Textures, once they have been rendered on a two-dimensional surface through rubbings or prints, appear to be patterns of varying degrees of regularity. They frequently resemble each other. They differ according to their density or openness, complexity or spareness, and in the distribution of areas of light and dark.

What rubbings do not reveal is the effect of light and shadow on a textured surface, and this can become crucial in a painting or drawing. The texture of a surface will affect the way in which light is reflected and the way shadows are absorbed. Light can be reflected from an irregular surface in a surprising number of ways, and it can frequently be more significant in identifying a texture than the two-dimensional patterns that it would otherwise form. The quality of light which falls on an irregular surface, if it is represented by variations of tone and accompanied by even the slightest suggestion of an outlined form, can often represent a texture without the elaboration of any pattern at all.

Compass, *pencil on paper. A metal compass unexpectedly disintegrates into fine strands of wire in this well-executed rendering of textures.*

Light Bulbs, *charcoal and pencil on paper. A glass bulb turns itself convincingly to marble.*

Ink Bottles, *charcoal on paper. The finely rendered bottle has exchanged its glass structure for wood in a successful transformation.*

We have already discussed the talents of Andrew Wyeth in the rendering of a great variety of textures, but a careful examination of his work will reveal that many of his textured surfaces consist primarily of generalized irregularities interrupted by highlights and carefully placed accents of darkness. In his paintings, Wyeth frequently uses what a cook might define as a "basic brown sauce." This is a rich, varied mixture of ochres, grays, and whites, often accented with browns and blacks, which with a few additional touches of a dry brush, he transforms into a distant hill, a ploughed field, a bed of flowers, a stretch of grass, the bark of a tree, the peeling wall of a house, the texture of rough cloth, stone, fur, sand, and sometimes the sea and the sky. The brown sauce of his paintings has its equivalent in his drawings, where a variety of pencil tones and irregular lines serve the same descriptive purposes. By superimposing the outlines of bricks, stones, wooden boards, or vegetation over these irregular surfaces and then adding the appropriate highlights and shadows, Wyeth can bring any of these substances to life. I should, however, add the caution that Wyeth has a great mastery of the effects of light, and that the reflectiveness or the opacity of his generalized surfaces contributes in a major way to the convincing quality of his textural renderings. To acquire this, nothing less than the constant practice of correct observation is required. But the study of Wyeth's work can help.

Another artist of interest is Walter Murch, noted for his moody and evocative still lifes, often combining old parts of machinery with natural materials. A rusty carburetor, a piece of rock, and a lemon relate to each other in Murch's painting in odd juxtapositions and unexpected harmony. A subtle quality of light unites them, yet they exist independently with a strong material and tactile presence. All of Murch's work deals, in various ways, with textures, yet they are inseparable from the existence of light: a light bulb, an old sewing machine, a piece of stone, a loaf of bread, a broken doll, an onion, a melon, these appear, convincingly textured, yet it is through a special quality of light that they make their presence felt. Nearly all of his paintings and drawings were developed from an overall, generalized, textured background, a field of irregularities and contrived accidents applied without reference to a specific image. Murch often spoke of his lack of inspiration in front of clean paper and untouched canvas, so he devised an unusual system for developing stained and suggestive surfaces. He left paper and canvases on the floor of his studio and on his working tables. He walked on them, dropped paint and ashes, broken charcoal, dirt, and solvents on them until the surfaces began to develop a character, a suggestiveness, and an incipient imagery in which he could search for those same presences that Leonardo da Vinci found on ancient walls.

Walter Murch was, in fact, an excellent abstract-expressionist who knew how to create an animated field, and a masterful fabricator of irregular surfaces. The papers on the floor of his studio were really an experimental search for more varied and accidental textures than the sometimes mechanical ones he knew very well how to produce. Once the field existed, he could work with surprising speed and ease. A favorite stone, an old brick, the works of a clock, an old rug, a rusty pipe, or a clove of garlic would quickly appear, illuminated and alive, from out of the surrounding space.

Murch loved textures, and he once said, "I have always felt that certain things were paintable — wood, marble, cloth, jewels, metal, stone, alabaster, black marble, rust . . . I would imagine them within a rectangle, like an already formed painting." What turned these textured objects into paintings, however, was always light, the illumination of a hard metallic edge, the soft glow of a curve of glass, the dark shadows absorbed in the side of a stone. Textures break up light, but light and shadow define form, and they endow Murch's subjects with extraordinary clarity and presence.

For many artists, the act of drawing, of seeing and rendering, can be too

quick, too direct, and too familiar to permit the lingering association and extension that art requires. An image can sometimes emerge too quickly, too stark and naked, and a technique is then required to slow it down, to soak it in associations, to draw it out of materials rich in suggestiveness. The evocative surface, the animated field, the "brown sauce," can serve to slow down the speed of work and to place the artist where he can draw his image out of a substance and not just put it in.

The purpose of these digressions is to suggest that there are many indirect ways to render, and sometimes they are preferable to frontal attacks. The images of an artist are created from substances which have a physical character of their own, and an artist must become sensitive to these. He must learn to respond to materials, respect them, and make them work for his ends. The animated field and the evocative surface are ways that allow the artist to become involved with, to manipulate, and to feel the character of materials. His aim should be to let it become the image, as if spontaneously and of its own accord.

It is possible to create textures directly, by the manipulation of patterns. It is also possible to create generalized patterns and to bring them to focus on a desired texture. Every artist will be well served by a knowledge of fields, of accidental surfaces, of generalized textures. However, in the rendering of a specific image, it is important to remember that light and shadow are the creators of form, and by the manner in which they play on a field they can either destroy or bring into sharp focus the illusion of a particular surface.

After you have struggled unsuccessfully for some specific effects, try for none. Try for a generalized surface, for chaos. You will find that it is not easy to draw nothing, but the effort will teach you a great deal about materials. As you find your way out of chaos, as you try to clean up a mess and define a form, you will learn many secrets of the masters. This is one of the better ways to acquire a mastery of your own for expressing the textures and the surfaces of things.

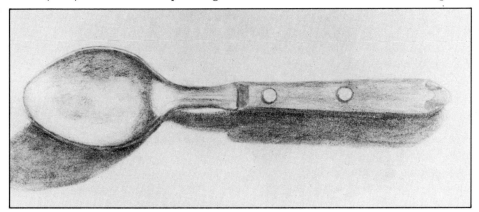

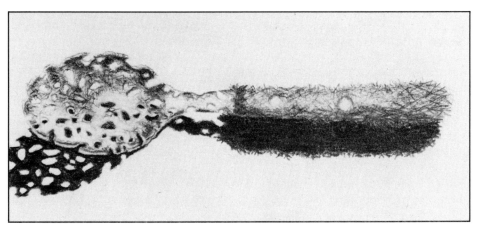

Spoons, *pencil on paper. A spoon disintegrates while its wooden handle develops a hairy texture.*

13　Accumulations

In a rubbing, in a print, or on a flat surface, textures are repeated patterns. In nature, textures are repetitions of forms, concrete elements, continuous or discontinuous units, and they belong to many different categories. They are produced by animate and inanimate matter as a result of growth, geological change, or human intervention. Every continuous substance, every skin, every surface, every accumulation of materials has a texture, so that the word lacks meaning in relation to nature. It is an artist's term. The natural world produces vegetation and animal life, decay and moisture, coverings and deposits, all of which are the result of distinctive processes involving the tendency towards repetition and proliferation.

Many of the forms and surfaces in nature which suggest what we call texture are the result of duplications of units, accumulations of similarities, and repetitions of elements. We have seen this in the division of leaves, in fish bones, in seed groupings, and in the structure of flowers.

Quantity and repetition are among nature's many devices for the assurance of growth and survival. Tiny steps, infinitesimal advances, sheer numbers often account for the progress of living forms. Flowers open, trees leaf, grass turns green in stages invisible to the naked eye. Forests grow, cells divide, fruit ripens, corpuscles multiply, water evaporates, clouds form, billions of tiny drops descend as rain — all in steps that cannot be closely defined. These acts of nature are constant cycles of minute events, infinitely multiplied.

Repetition, change, and similarity are natural phenomena that have given rise to our notions of time, number, and quantity, to alphabets and languages. Because through these devices we have learned to understand by analogy and sequence, it has been difficult to absorb the notions of infinite time, of infinitesimal change, and of numberless quantity. It has been equally difficult to understand the occurrence of change through the device of repetition, which is an essential part of the process of evolution.

We have seen that the repetitions of nature have a rhythm which results from irregularities, slight variations of sameness, sometimes minute deviations from the normal, and it is through these accidental occurrences that nature has been able to effect change, to adapt, and to vary. It was Charles Darwin's peculiar genius to unravel these mysteries. The evolution of species occurred through a series of invisible steps in which change was hidden behind a façade of repetition and similarity.

Lizard, *paper clips and spoon. Paper clips and a spoon make a convincing, crawling lizard in this imaginative solution.*

Crocodile, *wood bark. Fragments of glued wood bark make an imaginative crocodile in this version of an accumulation.*

109

We do not need to start at the beginning of time to make a construction based on the idea of repetition, but it is important to understand the role this notion has played in the creation of the forms of life. If we consider the patterns and textures of animal fur we can see that we are dealing with the particular manifestation of a general principle which relates the hairs of an animal to the growing of grass and the falling of rain. A sandy beach and a flowing river, bird feathers and ripening fruit have all been brought into being by the accumulation of large quantities of similar elements and by endless acts of repetition, and they share this process in common.

The principles of nature can help us perceive, in a bag of nails, in a box of paper clips, in a collection of corks, the possibility of creating form by accumulation, by joining, and by repetition. If we are artists, the sight of a large quantity of related materials can stimulate our imaginations so that we begin to see the parts growing together, structures coagulating, forms solidifying, and even animals struggling to be born.

The Problem

This problem involves the use of an accumulation of repeated materials that are to serve both as an invented texture and as the structural units for a three-dimensional construction in the form of an animal.

Since textures in nature are the result of accumulations of small units, it should be possible to create an invented texture by using a large quantity of small, similar objects and joining them together to form a novel and unexpected texture. The objects can be ordinary, plentiful, and inexpensive things. To use them in creating the shape of an animal, either real or imaginary, may serve to give direction and add interest to the problem.

Paper clips, corks, bottle caps, pins, toothpicks, matches, and nails are household items that are cheap and available in quantity. They are entirely acceptable as materials for use in this problem. Dried leaves, bark, straw, pebbles, sea shells, and other natural products may also be used. The choice of materials is unrestricted. You should give careful thought to this selection because the basic unit of your construction is everything in this problem. As so often is the case in art, searching for and finding the right materials is more than half the creative achievement.

You should judge your solution according to the consistency with which you use a particular material, its effectiveness in suggesting a texture, its success in serving as a structural device, its resemblance to an animal form, and the imagination and ingenuity expressed in the result.

The Construction

The materials you select must be able to suggest a texture while at the same time serve as a structural device, and it may be impossible to separate these functions. The way in which the units are held together will affect the way they suggest a texture. They can be overlapped like fish scales and roof tiles, clustered like seeds, woven like wicker and straw, tied, hooked, interlocked, welded, or glued. They can be joined, fitted, or attached so that they are side by side, end to end, or back to back. There may be wide or narrow spaces between them. They may be loosely adhering or tightly bunched.

The character of the materials you select will largely determine the decision you make concerning the proper method for joining the parts. Structural needs will also affect this decision and may turn out to be the chief determinants. Before you reach a decision, take the time to examine all the possible ways the materials you have selected can be combined. You should strive, of course, to create an effective surface and an interesting texture.

It may be necessary to use a material other than your basic unit to act as a holding element or surface. The parts may need to be tied together by wires or threads, or held in place by tacks or nails, or provided with a base of cloth, wire

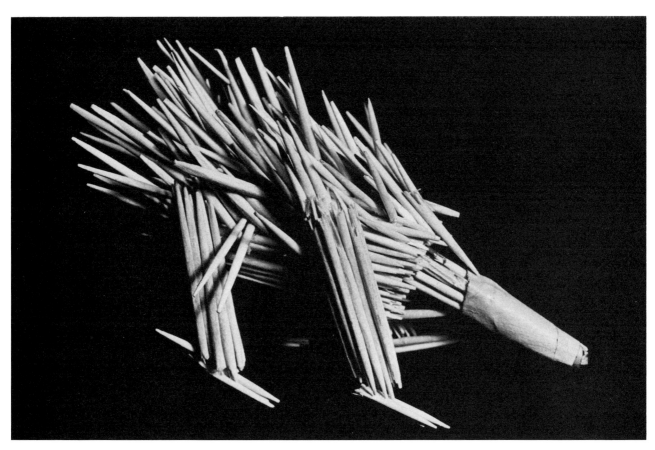

Porcupine, *toothpicks and paper. Glued toothpicks make a believable porcupine with a paper snout.*

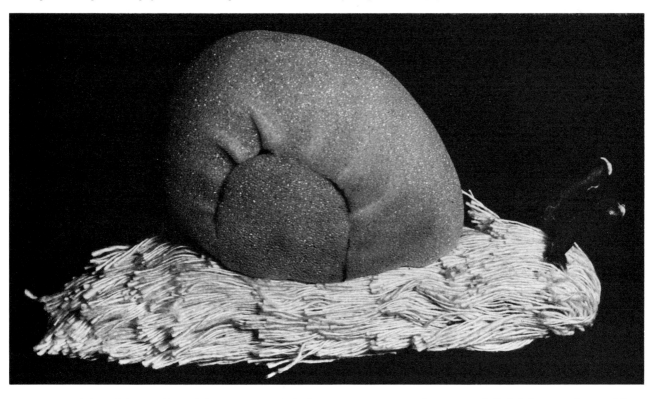

Snail, *string, cloth, and foam rubber. Tied strings create the body of this convincing snail carrying a shell of cloth wrapped around foam rubber.*

mesh, wood, or metal. If these are required by the nature of the materials and if they are used discreetly and effectively, there can be no objection to the use of additional materials. However, they should not intrude on the surface or become so prominent or noticeable that they interfere with the intended textural effects.

It may be that structural considerations will incline you to combine the equal or unequal use of two different, basic materials. Although this can be an acceptable solution, it is likely that the more striking effect will be produced by the consistent use of one basic material only.

In terms of construction, this problem involves the use of what architects call a "module." This is a surface, a structural unit, or enclosure, repeatedly used as the main element of a façade or of an entire building. It can also refer to a dimension or proportion that was used by the Greeks in the construction of their temples. The height of the columns compares to the distance between them in the ratio of 1.615 to 1. Giant blocks of stone, cut to similar proportions, were the modular units out of which the pyramids of Egypt were built.

Bees make their modules out of wax. Twigs, straw, and feathers serve as the modular units for the nests of birds. Grains of sand are the modules of an anthill.

Habitations have almost always depended on modules, whether their construction was of straw, lengths of wood, twigs to be covered with mud, leaves, or animal skins. Concrete blocks and bricks, roof tiles and shingles, wood and aluminum siding, prefabricated walls and windows are all modular units. They are essential to the building industry, and standard-size modules are becoming more and more prevalent in modern construction. Unfortunately, the 1.6 to 1 proportion of the Greeks has given way to the 2 to 1 or the 8×4 panels of pressed wood, plaster board, Masonite, and other interior and exterior finishing materials on which most standard housing is based. Only plastics seem to offer a way out of the increasing monotony of our buildings, unless we can learn to make better use of the imagination of our architects, designers, and artists.

Modules are essential to the production of any objects in quantity, but they do not preclude invention and imagination. The mosaic murals and wall decorations of Byzantium and early Christianity have clearly demonstrated the contrary. Before the 12th century, Polish, Yugoslav, Russian, Italian, Greek, Turkish, and Persian artists created some of civilization's greatest works from half-inch modules of fine glass.

All the modular structures of modern architecture and antiquity, the achievements of artists and designers of the past and present, and the varied works of nature are available to you as models for this problem even if they only serve as spurs to your imagination.

You may find that modular construction imposes some restrictions when it comes to providing for the legs and tails and heads and eyes of an animal. However, unless you find it impossible to do without, it would, in my opinion, be better to avoid the addition of new materials to meet this problem. It may be that your animal must be satisfied with a stubby tail, fat legs, and an undistinguished head. It may have to manage without eyes and nostrils and ears. Notwithstanding this misfortune, I believe that the solution will be more effective if you can restrict yourself to the use of one basic material.

Most animals are essentially cylindrical, although some may be flattened in one direction or another, like the turtle or the flounder. The main body usually stands above the ground on two or more supports, and your structure should be able to cope with this need for elevation, although it does not need to be great. It may be necessary to extend the head and and tail beyond the boundaries of a cylinder, which is simple in the case of a squirrel or giraffe. These are all matters to consider as you work to solve this problem.

It may be, and undoubtedly it should be, that the basic material you have selected determines and suggests the animal you should construct. If it does, the

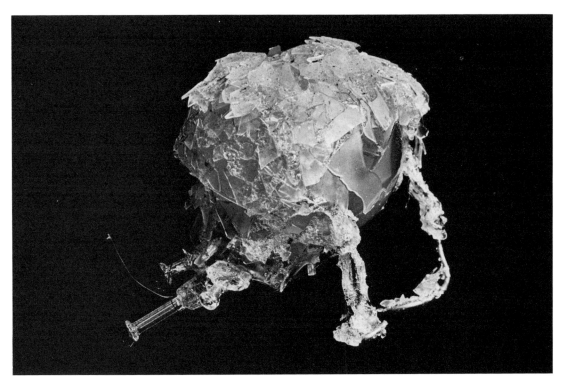

Rodent, *light bulb, wire, and broken glass. This imaginative animal, made of the glass from a broken bulb, is supported in the middle by a whole light bulb, the socket of which forms the tail.*

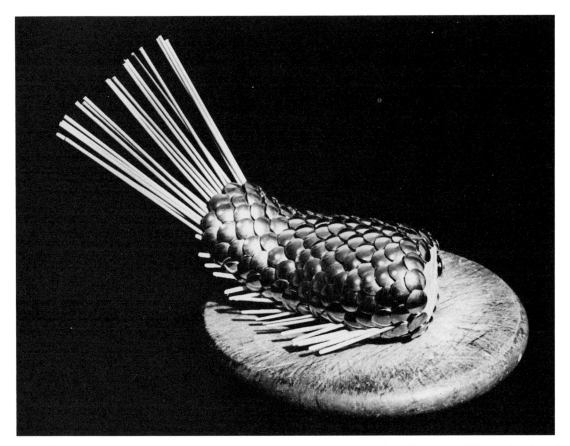

Fish Slice, *thumbtacks, wood, and plastilene. A core of plastilene supports a tail and fins made of thin wood sticks and an imaginatively conceived surface of thumbtack scales.*

problems of heads and tails and elevations will also be suggested by the materials themselves. This is the best way to arrive at a solution.

If you are to succeed with this problem, then the texture, the structure, the joints, and the image must blend together to make a coherent whole, a convincing animal. The material must serve as texture and structure simultaneously. All the parts must seem to have been born to fit together, and the whole animal must seem to depend entirely on its parts. You will have been completely successful if your animal seems to be the unavoidable and inevitable product of the nature of its basic materials.

This problem calls for the exercise of your perception as artists, of your ingenuity as designers, of your experience as builders, and of your best understanding of nature. You will also need a sharp eye for such mundane objects as paper clips and thumbtacks; as well as patience and luck, a great deal of dexterity, and a superabundance of imagination.

Bird, *straight pins and lead. This delicate standing bird is made entirely of straight pins, finely welded together – a very pure and ingenious solution to the problem.*

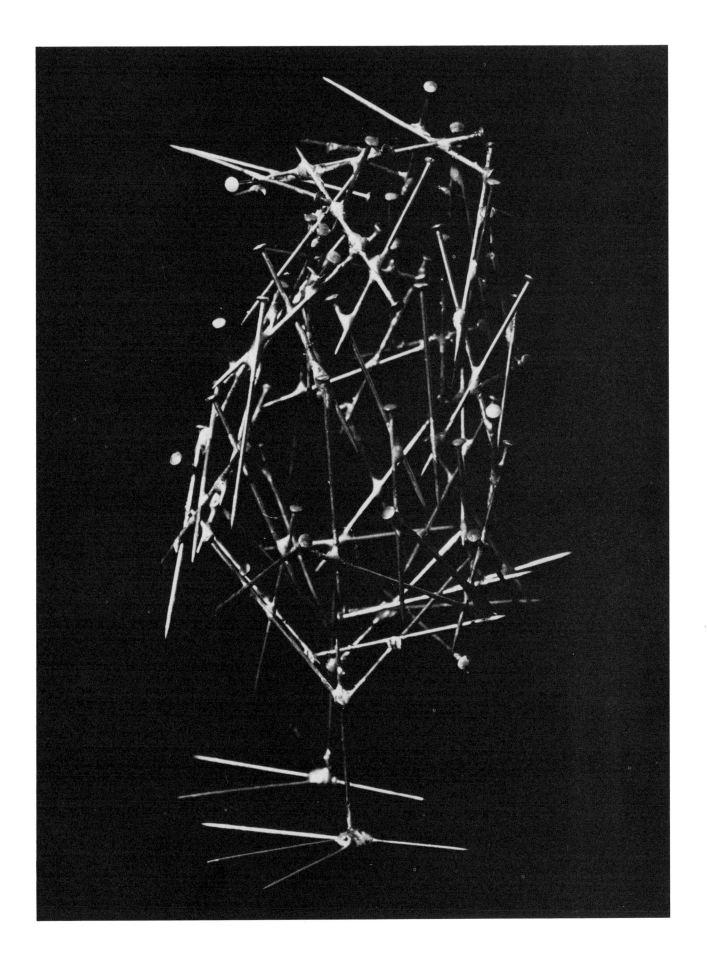

14 Bones

"I have an absolute passion for bones. . . . Have you ever noticed that bones are always modelled, not just chipped out? One always has the impression that they have just been taken from a mold, after having been modelled originally in clay. No matter what kind of bone you look at, you will always discover the trace of fingers. . . .I always find the fingerprints of the God who amused himself with shaping it."
Pablo Picasso

Our current problem deals with bones — animal bones. We have talked of trees and plants and leaves and seed and fish, but the animal kingdom, which is the next aspect of nature we should investigate a bit, begins with bones. Beneath the wild, strange life of animals and their world of nature, beneath their furry, prickly, smooth, or tough hides lie skeletons — skeletons made of bones. Bones are made up of dead and of live cells and are remarkable for the fact that they work and support even as they grow and change.

If you go to your neighborhood butcher and ask him for a beef bone he will very likely give you one free. A leg bone — a humerus, tibia, or femur — is probably the easiest to get and most useful. It will have tissue adhering to it, and this is interesting because you can see the subtle and complicated way muscles adhere to bones, through tissues connected to the live outer cells of the bone and tendons reaching into the complicated twists of the joints. As you boil the bone you will destroy the outer cells and loosen the tissue. You should remove the marrow from inside the bone and also the live cells of the inner bone. When you have boiled it for several hours, and mildly bleached it by adding bleach to the water, the bone will be clean and without smell (during the boiling the smell will be very bad at one point). The bone will then also be very brittle, since only the dead cells will remain (the live cells lubricate, cushion, and reinforce the dead ones). You must then be careful with it since it breaks like china.

The Problem

When you have a clean bone, draw it from four sides. Draw two views of the side of the bone, and one view of each end, at the joint. These four drawings should be on one page. On a separate page, draw two diagrams (these are not to be drawings, only diagrams) indicating how the joint could function in a coupling with another bone. This need not be how it does, in fact, fit with the adjoining bone. The purpose is simply to encourage you to contemplate the useful and varied connections of which these beautiful shapes are capable.

The Drawing

I would like you to examine the outward appearance of a bone for a few minutes. You will see that it contains all those qualities characteristic of forms in nature. It suggests harmony, balance, and function. The two ends, with their rounded, hollow, and convex shapes, obviously are capable of interesting interlockings with other forms, and yet they are also interrelated and sufficient, esthetically, to each other. Hollows and mounds balance each other. Similarly, the two ends,

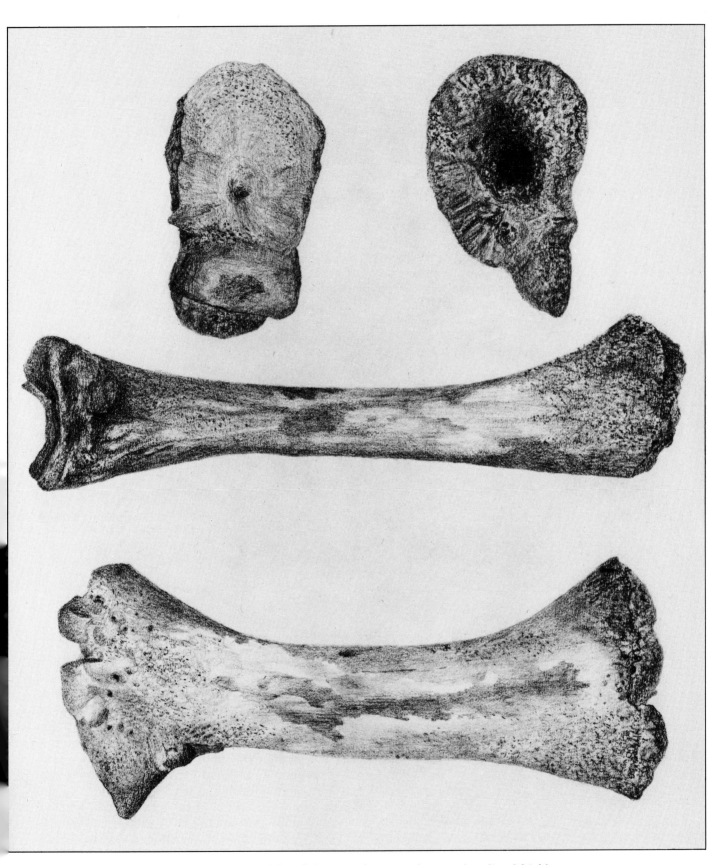

Four Bone Details, *pencil on paper. This careful rendering strongly conveys the textural quality of dried bones.*

connected by a tapering and enlarging center, create a harmonious balance for each other, flow out of and into this center. This self-sufficiency of design is typical of the forms of nature, and this is one reason for becoming excited about bones. Every artist will want to keep one in his studio and contemplate it from time to time, for this harmonious coherence has a significance not only for nature but for all art.

Speaking of art, a Chinese artist once said, "He who wants to draw a tiger must be a tiger," and this is, to me, as useful and profound a statement about drawing as I have ever heard. If you are drawing a model in a certain pose, for instance, you cannot simply draw what your eyes see, a cold design of lines, a grouping of forms, but you must feel the pose in your own body. If you are to recreate a pose that seems alive, you must put life — your own — into your creation.

I don't know if you have had the experience of trying to draw a mouth whose expression was particularly difficult to capture and after a long and futile struggle have found that your own lips began to form the expression of that difficult mouth — and then suddenly that the correct expression has appeared in your drawing. This is what the Chinese artist meant. "He who wants to draw a tiger must be a tiger" means that for the act of re-creation which is drawing the artist must become, by association, by empathy, through some subjective mimicry, what he is drawing.

What has all this to do with bones, with objects, with dead things? They, too, must somehow come to life through an act of involvement. The object must become a real thing. The excitement of the shape, of the texture, of the form, must become more than an observation. It must be real, personal, and subjective.

We know a great deal about bones from eating, from art, from our own bodies. Every joint of our fingers and our feet, our elbows and our knees, our shoulder blades and spines and hips gives us information about bones, and gives us a basis for identification. Our knowledge of shapes and textures does the same thing.

To an artist, a bad drawing is the depiction of a form which we can only identify with our minds — a sort of outline that indicates a shape, without convincing. To convince the viewer that he is seeing something, a drawing must contain impressions of the artist's conviction, his involvement. An object is not the outside shape, nor even the obvious shadows and highlights, but its presence from inside. In art, the presence from inside is expressed through the artist's materials. A bone, truly rebuilt of charcoal, absolutely constructed from charcoal, becomes a reality on paper. The artist's concentration on the charcoal, on that paper, and his own ability to believe that a real bone is coming to life through this material, more real perhaps that the real bone, is what makes the drawing of a bone come to life. Don't worry too much about the bone. Feel it, then recreate it through the charcoal and the paper: "He who wants to draw a bone must be a bone!"

Bones

I would now like to ask a few questions, scientific and esthetic, about the construction of a bone, inside and out. For instance, a bone is relatively thin along its shaft and thick at both ends, or joints, yet if you look at a cross-section of the inside of a bone, the opposite is the case. What is the meaning of this?

The most solid part of a bone is along the shaft. The thickest part is right in the middle. The surface at the joints is thin, but the inside is criss-crossed by a paper-thin honeycomb of fibrous material (see Figure 30).

First, let us ask a question about the general shapes. Why, realizing that a bone must be capable of great strength, is the main shaft cylindrical? Well, it turns out that a cylindrical form, like the trunk of a tree, like the stem of a flower, like an underground tunnel, is the only form capable of resisting pressure from any direction, from any one of 360°. Our rigid buildings are made of

Figure 30. *The cross-section of a bone.*

118

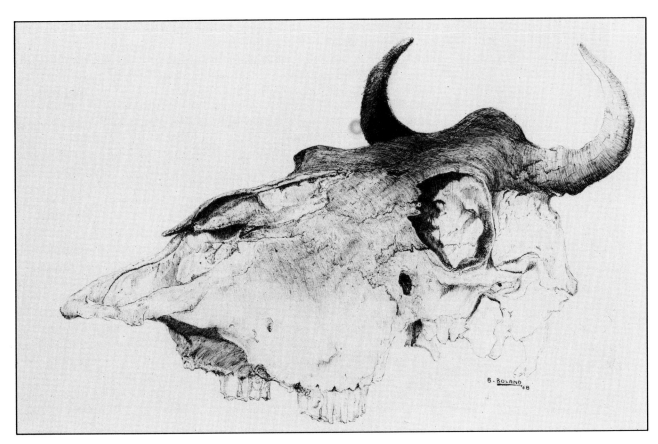

Cow's Skull, *pencil on paper. Delicate lines uncover the intricate hollows and angular surfaces of a cow's skull.*

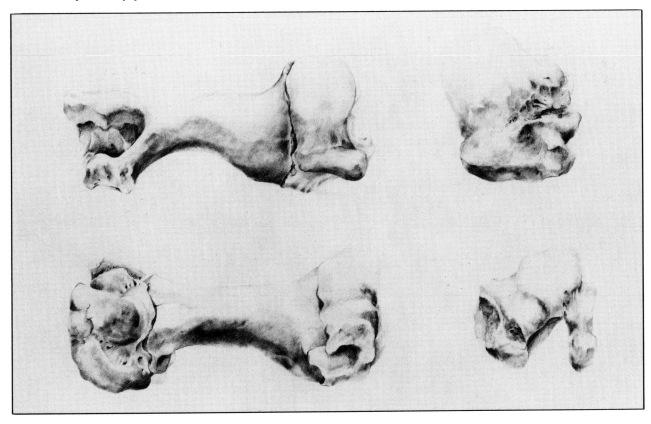

Bones and Joints, *pencil on paper. A sensitive rendering of the mounds and hollows which make up the forms of bone joints.*

steel I-beams, but these can only resist vertical pressures and some horizontal ones. They are not asked to deal with forces from other angles. The bone of an arm or a leg, on the other hand, must be subject to pressures from almost any angle, hence the cylindrical shape. But now we should ask, why should it be a hollow cylinder?

Obviously, a hollow cylinder has the advantage of economy of weight and materials over the solid one, and this is equally true of the I-beam, which is basically a hollowed-out rectangle with the main lines of force-resistance kept in. The top and bottom sides of the I-beam also become involved in another principle, which we have discussed before in relation to tree branches, of the forces of tension and compression, and this is true of the hollow cylinder.

If you have a solid cylinder which, on one side, is subject to pressure — to compression — then the entire thickness must respond to that compression and, if the force is great enough, the whole will break. If, on the other hand, the cylinder is hollow, the side not under compression is subject to tension. If the materials it is composed of have any flexibility, then the tension forces can, to a certain extent, combat the compression forces on the opposite side, and this is what happens in a branch, in a wheat stalk, and in a bone.

Why is the bone cylinder thicker in the middle? Because this is where it is weakest when both joints are under pressure. If you were to take a long stick or rod, with both ends firmly held and subject to equal pressure, increasing to the breaking point, the break would occur in the middle. Therefore the bone is reinforced in the middle, its weakest point.

Now let us examine something more complicated, but fascinating: the cross-section at the joints. The outer-surface here is thin and fibrous materials fill the entire head. They follow an intricate pattern with some evident but not necessarily obvious logic. The logic, in fact, was not understood before the 1860's, when it was brought to light, reasonably enough, by an engineer.

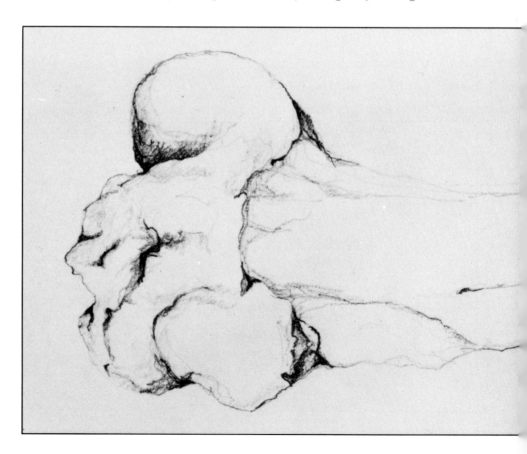

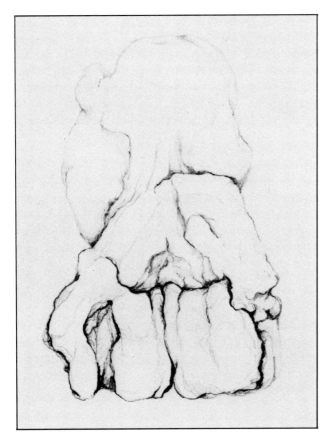 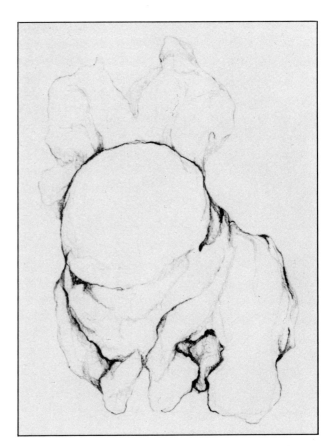

Three Views of a Bone, *pencil on paper. Dispensing with the use of tones almost entirely, these drawings depend on sensitive line to capture the complex shapes of bone joints.*

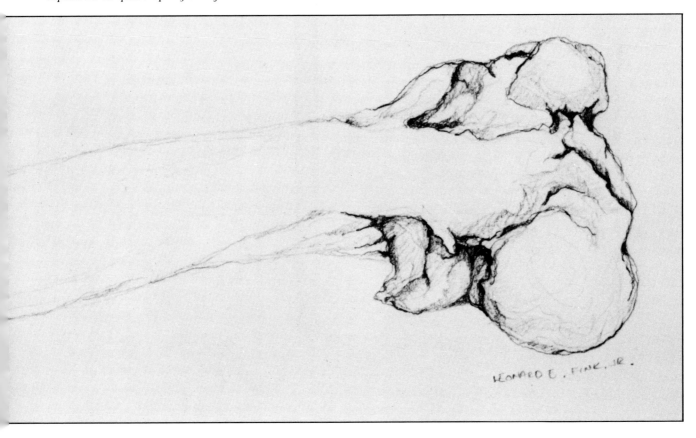

If a block of wood is cantilevered out from a wall (see Figure 31), fastened to the wall at points A and B, and subject to a downward pressure, X, the compression forces can be represented by lines. The compression forces press against the point, B. At the same time, inevitably, the point, A, is subject to pull, or tension forces, and these forces act in a direction exactly opposite and complementary to the compression forces (Figure 32).

Now, if we look at the head of a bone in a greatly simplified cross-section, we can describe the compression and tension forces that could be acting on it in a way very similar to the block of wood (Figure 33).

The lines of forces direct themselves towards the two, thicker sides of the bone shaft. They are, of course, multiple and complex since they can come at any angle and from any direction. Furthermore it is not a flat plane, but an irregular solid, which means that any cross-section will not be limited to the lines of force acting only in that plane. However, the honeycomb arrangements of the fibers inside the head of a bone correspond exactly to compression and tension lines from all the principal directions implied by the outer shape. They serve, in a sense, as conductors for all the forces that could be acting on the bone head, directing them towards the point of greatest strength: the thickened, cylindrical shaft of the bone itself.

Nature's solutions are immensely subtle and intelligent, and they always represent multiple, interrelated solutions of the kind that we have only the crudest means for imitating. The same complexity and self-sufficiency that we observe in the outward appearance of nature operates in its internal construction, and the two manifestations, of course, are one and the same.

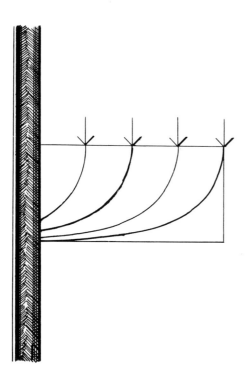

Figure 31. *Downward lines of pressure acting on a block of wood attached to a wall.*

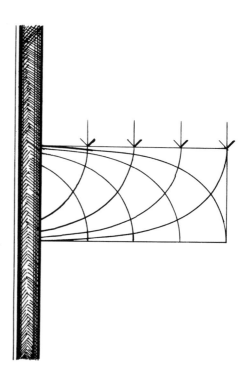

Figure 32. *Tension and compression forces acting on a block of wood.*

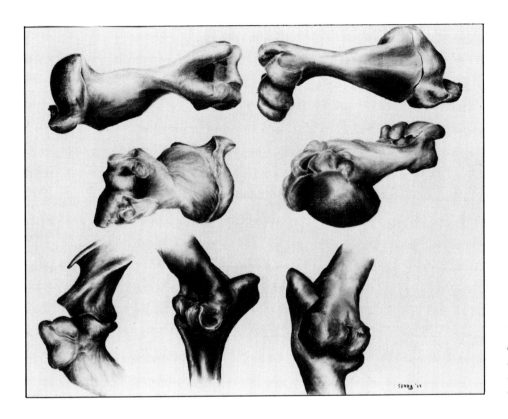

Seven Views of a Bone, *pencil on paper. With a masterful control of tones, this drawing reveals the detailed structure of bones and joints.*

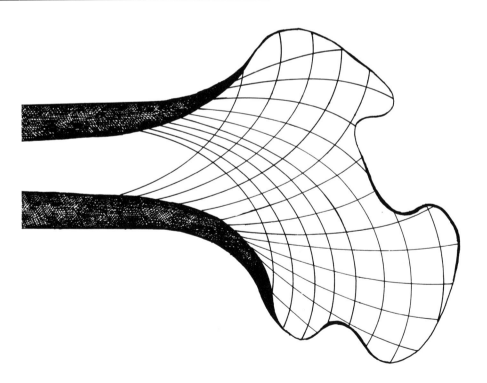

Figure 33. *A cross-section of the head of a bone showing potential lines of tension and compression.*

15 Animal Inventions

We have already created animal structures based on ideas derived from an examination of textures. Animal textures are obviously not a negligible aspect of their appearance. Some animals — fish especially, as we have seen — have a highly identifying patterned exterior; others do not. What vertebrate animals do have in common is an animating, articulated skeleton. This skeleton supports their weight, determines their method of locomotion, their physical capabilities, the shaping of their skin, the placement of their muscles, and their general external appearance.

It is almost unavoidable, when examining the animal world, to contemplate the problems of evolution — the fact that all forms of life are interrelated and have their common origin in the sea. The most striking aspect about the skeletons of vertebrates is that — despite the extraordinary variety in nature — men and birds, sea animals and elephants, all share a common skeleton. Turtles have ribs, shoulder blades, and pelvic bones just as man has. Elephants have kneecaps, heel bones, and elbow joints that are almost identical to man's. The upper wing of a bird, like the upper arm of a man, consists of an almost identically shaped humerus bone. The entire vertebrate world, in fact, operates on the same four-leggedness, the same rearward pelvic bone, forward or upward rib cage, collarbone, and shoulder joint, the same spinal column of joined and separated vertebrae. The claws of a cat or a bird represent an adaptation of the same group of forms as those which account for the shape of a man's feet and hands, a duck's webbed feet and feathered wings, and a horse's hooves. The moveable lower jaw of a man is of the same construction as the jaw of an anteater, a bat, and a buffalo. In short, the vertebrate skeleton is one of nature's major inventions. It is an almost rigid pattern which, at the same time, is capable of adaptation for flight, for underwater maneuverability, for upright standing, and for supporting great weight against the forces of gravity.

Lest I seem to generalize too unscientifically, let me say that there are certain categories of vertebrate creatures which do not have the full skeletal structure of mammals — fish and certain reptiles, for example. But, as we have seen with fish skeletons, they do consist of joined vertebrae in a system very similar to a spinal column. Their lower extensions are not unlike ribs in appearance and in function. Their tail bones can be seen as incipient pelvises, their fin attachments as incipient arms. The seal skeleton is particularly interesting as an example of a mammalian skeletal structure adapted to function in a manner very

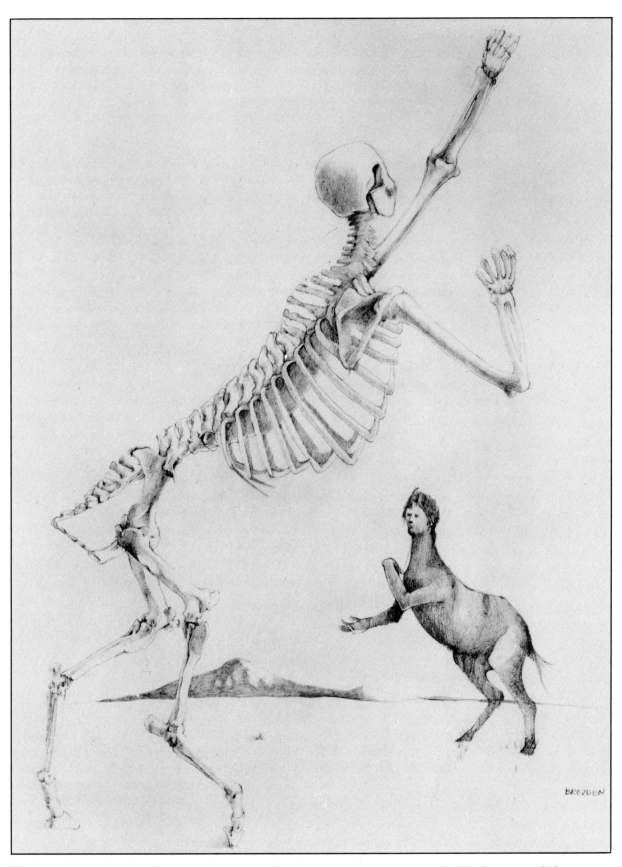

Centaur, *pencil on paper. This sensitive drawing details with understanding the substantial skeletal structure which supports a Centaur-like creature.*

similar to the movements of fish. Whatever the evolutionary facts — and they are complicated — looking at the skeleton of a seal, one can very easily imagine how the skeleton of a fish could evolve into that of a mammal. Snakes have a skeletal structure not unlike that of fish, but more rounded. It suggests dozens of rib cages of equal length in perfect alignment.

These are variations — simplifications — of the basic vertebrate skeleton, and the repeated use of certain forms, so characteristic of nature, is a source of great wonder to an artist.

I feel that as part of this problem it is important for you to take the time to examine the relationships of bones in a variety of animals, to understand, in a way that will serve you for the rest of your lives as artists, the extraordinary thing that is the basic structure of the vertebrate skeleton. You should look at real bones and skeletons, including the human skeleton, if it is at all possible. You should make the trip to a museum of natural history. Photographs in books are not adequate. When you look, you should marvel, not at the variety which is so often emphasized, but precisely at the similarities among the skeletons of different animals. Look for kneecaps and see how many species have them at the joint of the hind leg, and how similar their shape is. Look at feet and heel bones and see the subtle changes and variations which account for their seemingly myriad forms. Look at a bird's wings and see how miraculously the arms of men have been adapted to an entirely different use.

Perhaps you will find yourselves asking questions about this world of ours, which, in spite of all its mechanical accessories, is still basically and fundamentally the world of nature. I have often asked myself if man is, in fact, nature's finest creation and its ultimate goal. Are the arms and legs and skulls which we possess the most desirable, or are they one of nature's constantly changing and varied adaptations? If man destroys himself, is nature capable of creating equally adaptable, equally "advanced" forms of life? Evolution has not ceased. The basic forms of life are capable of many further mutations. Man, even alive, can still be bypassed by some more progressive form of life; undreamed-of creatures, yet other adaptations of nature's basic mobile structures, can still come into being.

The Problem

This problem is in two parts. First to draw the skeleton of an as yet unknown vertebrate animal and, to draw the outward appearance of this animal.

The animal is to be an invention of yours, a creature never seen before. It might be helpful to also write down a brief explanation of the habitat and habits of your invented creature.

It is important that you think out this problem with care. The skeleton you draw must be related to the external appearance of the animal you invent. It must also conform to the general principles which underlie the structure of all vertebrate creatures. Both the skeleton and the appearance of your animal must be consistent with its ways, its habits, and its environment.

The Drawings

In drawing the skeleton of an unknown animal, you must conform to the tried and true ways of nature. The vertebrate skeleton is a structure which conforms to certain rules of organization, and these must be followed. Your drawing, therefore, will not differ radically from renderings of other skeletal systems. This does not mean that your drawing needs to be dull. On the contrary, the human and animal skeleton is a very exciting structure, as the cases in any natural history museum will amply demonstrate. It lends itself well to renderings of both power and delicacy, as a glance at the drawings of Vesalius will make quite clear.

Take the time to study and to understand the basic constituents of the skeleton, the pelvis, the arrangement of the rib cage, the collar bone, the skull, the vertebrae, and the bones of the arms and legs. One purpose of this problem

Skeleton Invention, *pencil on paper. This well-drawn skeleton should permit the monkey-like creature to move about in lumbering fashion.*

Skeleton Invention, *pencil on paper. An imaginative skeleton is well-rendered in this version of a lizard or rodent-like creature.*

Skeleton Invention, *pencil on paper. The heavy bones of this predator are rendered in a drawing of considerable rhythm and grace.*

Animal Invention, *pencil and watercolor on paper. The heavy-boned predator reveals a dinosaur skin and an evil disposition.*

Skeletal Invention, *pencil on paper. These delicately drawn creatures have a skeleton that seems related to the horse.*

Animal Inventions, *pencil on paper. These gentle animals seem to combine aspects of both horses and cows.*

is to provide you with an opportunity to become familiar with the animal skeleton. It will be your guide in the future for understanding men and animals. It will provide you with a rich store of forms for the needs of your imagination.

In considering the appearance of an animal, you must give thought to its habitat, method of locomotion, and feeding habits. You should also give some thought to the animals it may prey on and, in turn, what other animals may consider it as prey. This will affect its coloring and its markings. These will also be affected, to some extent, by its need to attract a mate.

Your animal may be a creature that lives on land or in trees. It may be aquatic or amphibious. It may fly or live underground. It may move by running, leaping, digging, climbing, swinging, swimming, gliding, or flying. It may be carnivorous, piscivorous, insectivorous, herbivorous, frugivorous, omnivorous, or scavenging. All of these considerations will require adaptations of the mouth, teeth, tongue, beak or jaw, feet, legs, arms, hands, claws, or wings. You should give thought to these problems and provide a brief accounting of your reasons for these features.

In contemplating the effects of environment, it may be of interest to speculate on what may be only a rumor. I have heard it said that medical tests on the astronauts have revealed that, following prolonged exposure to weightlessness, their blood ceased to absorb calcium (at least while in the weightless state). If this is true, it would be a vindication of Sir D'Arcy Thompson's strictures concerning the mechanical aspects of the form of living structures. As Sir D'Arcy Thompson has said, "Where a force exists, there strength arises to meet it." He did not say, but could have, "Where a force ceases to exist, there a weakness develops in a structure." However, he did say, "Were the force of gravity to be doubled, our bipedal form would be a failure, and the majority of terrestrial animals would resemble short-legged saurians, or else serpents. Birds and insects would suffer likewise, though with some compensation in the increased density of the air. On the other hand, if gravity were halved, we should get a lighter, slenderer, more active type, needing less energy, less heat, less heart, less lungs, less blood."

Unfortunately, Thompson did not speculate on the effect of total weightlessness on the human organism but, as science fiction has already done, we can imagine beings born in a weightless state as having no skeleton at all, an enlarged brain, a shape like a balloon, with small clawlike attachments for manipulation. In this problem, however, we need a skeleton and, therefore fortunately, a creature affected by gravity.

The Skeleton

Sir D'Arcy Thompson in his extraordinary book *On Growth and Form* explains certain aspects of the construction of a vertebrate skeleton by comparing it, in a stable position, to the structure of the Forth Bridge in Scotland. This is a multi-cantilevered suspension bridge, one unit of which contains double columns for support purposes.

Like the elements within the head of a bone, which we have recently discussed, the design of the Forth Bridge is, in fact, based on the stress lines created in the relationship of a horizontal weight borne by vertical supports and joined by a flexible tie. In Figure 34, the dark lines represent parts of the system under compression, while the lighter lines represent the elements under tension.

In the animal skeleton, the fore and hind legs represent two piers from which the head and neck are cantilevered on one side, while the tail and part of the pelvis represent a cantilevered system on the other. To a certain extent, in a horse for instance, the middle section containing the viscera and the ribs also represents an inverted cantilever system.

The neck of a horse, like that of many long-necked animals, contains spiny projections on the neck vertebrae, which are referred to collectively as the withers. These projections also exist along the tail and lower spinal vertebrae of some

Figure 34. *Structure diagram of the Forth Bridge, showing double supports and two cantilevered sections.*

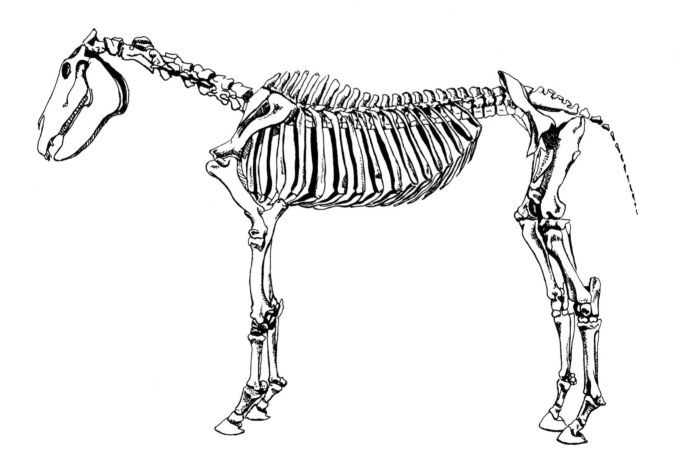

Figure 35. *The skeleton of a horse.*

Skeletal Invention, *pencil on paper. This somewhat human creature appears to have a workable, if rather heavy skeletal structure.*

Animal Invention, *pencil on paper. This is the worried result of a heavy skeleton and very mixed parentage.*

Skeletal Invention, *charcoal on paper. This ostrich-like turtle reveals its impressive skeleton and shell in a beautifully rendered and huge (8 × 4 feet) drawing.*

Animal Invention, *pencil and watercolor on paper. The ostrich-like turtle has hairy skin and a beautifully colored shell. It eats flies exclusively, capturing them by a unique suction process.*

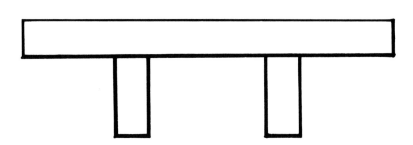

1. Two-armed cantilever bridge.

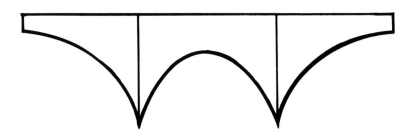

2. Stress diagram of a bridge.

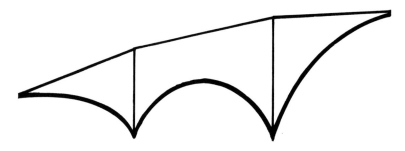

3. Stress diagram of a horse's backbone.

4. Stress diagram of a dinosaur's backbone.

Figure 36. *Comparative stress diagrams of bridge and animal forms.*

long-tailed and heavy animals. It is interesting that the spiny projections of the horse's withers gradually diminish in size towards the head of the animal and are angled, in relation to the neck, precisely in the manner of the compression braces of the Forth Bridge. In other words, the neck is a cantilevered suspension system in which the tension cables are ligaments and muscles, and the compression elements are the spine and vertebrae (Figure 35).

The ribs of a horse represent an inverted parabolic girder, with the back bone acting as a compression member. The sternum and the abdominal muscles represent the tension members, and the intercostal muscles and the ribs constitute the webbing.

It must be remembered that the structural requirements of an animal skeleton include carrying the weight of viscera and muscles, and that it is also a dynamic system capable of alternating weights among the pier supports and of shifting the loads very suddenly. In this connection it is interesting to note that the weight of most four-legged animals is heaviest towards the front. In the case of horses and elephants, three-fifths of the weight of the animals is carried on the forelegs. In the case of llamas and camels, twice the weight is carried on the forelegs. This, of course, frees the hind legs from a certain burden and permits them to function more efficiently as the pushing and propelling element. Dynamically, the location of the greater weight forward aids propulsion and adds to the thrust when jumping and galloping. When the jockey crouches over the neck of a racehorse, he is contributing to these dynamic requirements.

It may help, in attempting to visualize the relation of a skeleton to the structural requirements of a bridge, to visualize the simplified stress diagrams of comparative forms (Figure 36).

In the case of a dinosaur or heavy-tailed animal, the tail would represent a cantilevered system similar to the horse's head, with the lines of greatest stress reversed. In the case of birds, the weight of the bones themselves is greatly lightened, and the whole structure is aided by a complex system of inflatable air sacks which considerably alter the requirements of the structure, but which demonstrate yet another aspect of the flexibility of the vertebrate skeleton.

I urge you to read the work of D'Arcy Thompson if you are interested in a more detailed analysis of these structures. The purpose here has been to demonstrate some aspects of nature's logic, and to show some of the infinite adaptability of nature's structures.

16 **Skeletal Structures**

The structure of vertebrate creatures is very complex — from the texture of the adaptable and flexible skin to the incredibly articulated skeleton. This skeleton allows for the possibilities of change and motion, while maintaining the proper degree of tension and compression under all conditions of equilibrium. To ask you to create such a structure would be an extremely involved task. To re-create the outward appearance of an animal — perhaps the animal you have designed — would amount to little more than learning to make decorated, stuffed dolls. You could become involved in animating them, but this would take us away from the problems of art.

I think what does make sense is to ask you to consider the aspects of an animal that involve the relationship between a skeletal structure and a skin or a membrane.

These aspects will become even more evident if, for this problem, we concern ourselves only with static structures that have a relationship with space. In the case of an animal there is a skeleton, and this structure is generally totally enclosed in a skin. The skin is, to a certain extent, under pressure, so must be expandable, and therefore its shape is almost totally dependent on the underlying skeleton.

To create a static structure that is totally enclosed in a skin, although that skin may reflect the shape of the structure and may even be, due to elastic properties, intimately descriptive of the underlying skeletal system, would not be of as much visual interest as a partially open system, where the skeleton and the skin could more freely and openly interact. I am thinking principally of structures such as kites, where the need for air-flow requires the skin to be open in certain places.

There are, of course, many structures related to kites. Architects refer to them as membrane structures. Among the most obvious in our ordinary environment are umbrellas, but one can think easily enough of others, such as tents, windmills, kayaks, dirigibles, hammocks, Japanese lanterns, firemen's rescue hoops, and rubber rafts. More subtle in the relationship of skin to structure are the variety of the shapes of sails on ships and the different kinds of parachutes. In nature, too, there are leaves and flowers and fungi, such as mushrooms, which have this open membrane arrangement.

One of the most stimulating sources for ideas about open shapes is the world of invertebrates. There are, as a matter of fact, more species of insects than of all

Membrane Structure, *paper and wood. This bird-like kite has an interesting and solid structure beneath its membrane of colored paper.*

other animals and plants combined. The extraordinary number of shapes produced is endless, and you should make a point of examining at least a few of the beautiful, overlapping, and interlocking shapes of bugs, beetles, roaches, crickets, katydids, and grasshoppers. Shapes are not the only extraordinary properties of insects. A housefly, for instance, hums in the key of F. A caterpillar has 4,000 muscles (man has only 792). A beetle can pull 42.7 times its own weight. A fly beats its wings at the rate of 20,700 strokes per minute.

The world of marine invertebrates is another infinitely rich source of material for open forms and membrane structures. There are great varieties among sponges alone — venus flower baskets, fire, breadcrumb, finger, and red-beard sponges. There are polyps, sea anemones, coral, jellyfish, crustaceans, squid, stars, and sea urchins whose forms and structures should be examined, if only to spur the imagination.

I will reserve most of my comments, however, to deal with kites and with the structure of bridges, as these will be most helpful in relation to the practical aspects of this problem.

The Problem

The problem, as I conceive it, is to construct a skeletal structure surrounded in places by a membrane or skin. It may be in the shape of an animal, it may fly like a kite, or it may be a purely abstract construction.

The structure can be made of wood, wire, wicker, or any material you choose. It should be visually interesting but not necessarily complicated. It should be exciting. The skin may be made of paper, rubber, plastic, cloth, or string. For the sake of the skeleton it should be light in weight. The relationship of the skin to the skeleton should be real and meaningful and, if possible, the position of the open spaces through which the skeleton will be visible should have a reason, if not of function, at least of esthetics.

The Construction

Let me repeat something about esthetic logic: there is no esthetic logic except the logic of feelings. This means that if you truly follow the direction suggested by your feelings — to work with the sense of excitement which suggests your feelings are involved — you are likely to produce something in which all the elements work in harmony. It is this harmony that creates excitement, and which gives works of art their "logic."

The greatest danger you have to watch for is the logic of the mind, especially in a problem requiring as much clear thinking as this one does. The mind is subject to delusions of harmony and is given to simplifications that lead to the obvious, the conventional, and the safe. Excitement is what makes art work, and so you must start with something that you find exciting, whether it is a structure or a shape. With a structure, you must take your time to feel the meaningful and appropriate placement of the membrane. With a shape, you must discover the skeleton appropriate to it and the inevitability of the opening through which the skeleton is to reveal itself. Again, the simplest structures are always the best and if only for this purpose, logic can be of some help.

Let me mention a few of the commonest sources of artistic failure. They are roughly of four kinds which I would label: cloudy thinking, arbitrariness, excess, and poor workmanship.

Cloudy Thinking. Out of fear of doing the obvious, students will sometimes try to create non-geometrical structures, resulting in something that is usually unbalanced, overly complex, and without meaning. The desire for irregularity belongs to shapes and not to structures, and if you are so inclined, try to concentrate your emotions on shapes and use only the greatest clarity and logic on the appropriate, complementary structures.

Arbitrariness. It is possible to be guilty of arbitrariness in relation to membranes as well as structures. Some skeletons are simply covered here and there

Membrane Structure, *paper and wood. An interesting geometrical structure opposes a lattice work of delicate wooden strips, solidly joined to a square membrane of brightly-colored paper.*

Membrane Structure, *metal and paper. This well-balanced construction consists of open and closed triangular shapes suggestive of a seed pod. The metal is soldered and the paper has been waxed for greater strength and tension.*

139

with a membrane in order to fulfill the requirements of the problem, but without meaning, and without creating a shape that is satisfying in itself.

Excess. Too much emphasis on structure or too much emphasis on membrane are equal dangers. If the membrane covers too much of the structure a great potential for visual excitement is automatically eliminated.

Poor Workmanship. Materials have to be selected with some care (materials you know you can work with), and the problem of fitting joints has to be faced squarely as one of the more difficult aspects of the problem — whether to tie, to glue, to weld, to interlock, and if the material will suffice to hold your structure together. "It *was* a beetle!" is not always a satisfactory description of a shapeless mass of wood and paper!

As for color, keep in mind that you will be dealing with an already rather complicated relationship between a membrance and a skeleton, between enclosed and open areas, between a smooth surface and articulated forms in space, and color could easily confuse or destroy the excitement of those relationships.

Fumio Yoshimura, a Japanese sculptor who lives in the United States, has made some extraordinary structures of the kind we are talking about. Two, which seemed to be based on the forms of insects, were made of plain bamboo, about five feet long, and covered with a partial membrane of a semi-transparent white paper called Seki-Shu. The purity of the white membranes contrasted with the dark tan of the bamboo structures was all the color that seemed necessary. Each related to its function and overlapped with the other very harmoniously. No distractions intruded.

However, it is important in this problem that you should have fun, and, if fun requires you to use color, use it.

Membranes and Structures The design of bridges, the shape of roof trusses, the structure of kites — all can provide you with ideas and suggestions for a construction suitable to this project. Even the shape of sails.

The typical sail shapes shown in Figure 37 are among other forms in a book on pneumatic structures by Frei Otto. You should refer to such books — on architecture, kites, and on structures in general — to develop your ideas.

Figure 37. *The five basic sail shapes.*

The design of cable suspension bridges, of which there are some beautiful examples in New York — the Verrazano-Narrows, George Washington, the Brooklyn Bridges — lend themselves to many variations and interpretations of great usefulness. The designs of three other bridges which are, of their kind, the largest in the world (as of 1967) can be seen in Figures 38–40.

The value of bridges is that they suggest methods for joining small units. Of course, you can also think of your construction in terms of folded planes based on squares, rectangles, triangles, and circles — folded, bent, interlocking, and abutting — or in terms of solids such as cylinders, cones, or spheres in various combinations or sections.

Figure 38. *Kill van Kull Bridge in the United States. As of 1962, it was the longest steel arch span in the world, with a span of 1,652 feet.*

Figure 39. *Sando Bridge in Sweden. As of 1962, it was the world's largest single-arch span made of reinforced concrete. Length: 866 feet.*

Figure 40. *Quebec Bridge in Canada. As of 1962, it was the world's largest bridge made of a combination of arches and cantilevered half-arches connected by trusses. Its span is 1,800 feet.*

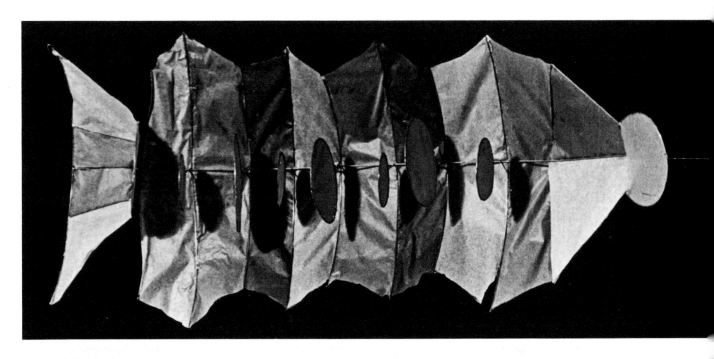

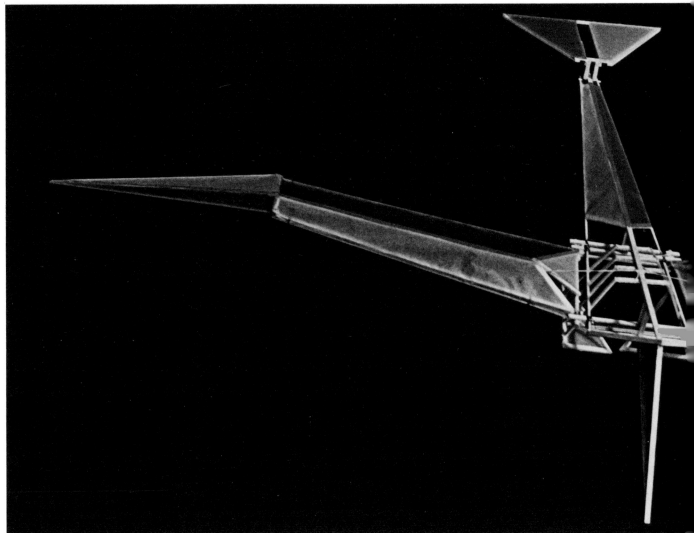

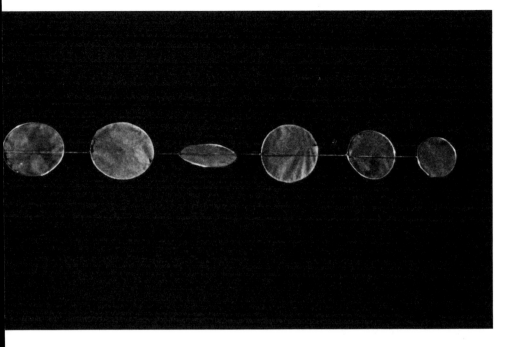

Membrane Structure, *paper, wood, and wire. This kite-like structure creates an interesting relationship of shapes supported by a delicate structure of wire and wood.*

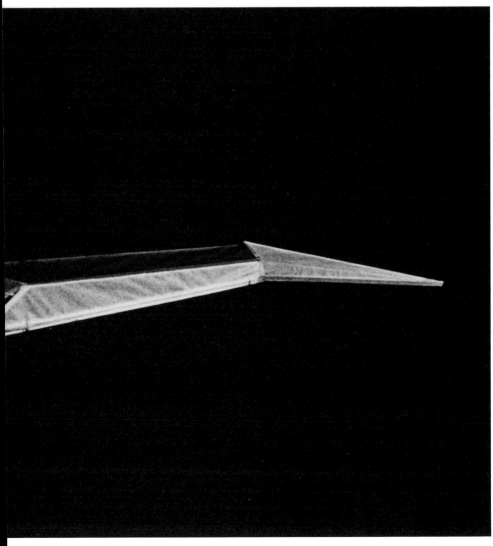

Membrane Structure, *paper and wood. A delicate airplane-kite that glides, this construction has intricate joints that move the wings and the tail.*

Kites Let me say a few words about kites. Like so many other things, they originated in China thousands of years ago. The Chinese used them to carry fireworks, to hold out fishing lines, to drop bombs, and to frighten people by attaching bells and pipes to them. On our side of the world, kites have been used for many practical purposes. For instance, they have served as gunnery targets, to drop leaflets behind enemy lines in war (the U.S. Civil War), to lift men as lookouts (by German submarines), and to hold up radio antennae for fliers downed in the Pacific in World War II. They were also used by the U.S. Weather Bureau for meteorological observations until 1933, when they became a menace to aviation. Planes flew rather low in those days, and kites flew high, as high as 31,955 feet (a record set in 1919).

It was Benjamin Franklin, as we all know, who started a real craze for kite flying in 1752, especially for those who wanted to repeat his experiments with lightning and who got a kick out of getting and giving their friends electric shocks. Franklin used the standard, flat, diamond-shaped kite, which had been in existence since the old Chinese days, and needed a tail for stability.

It was not until powered flight began to seem an actual possibility, near the end of the 19th century, that new kite designs began to appear in great variety. One of the leading contributors was an Englishman named Lawrence Hargrave who is given credit for the invention of the box kite (Figure 42). Hargrave worked on the then recently expounded theory that two or more superposed planes could add lift more effectively than one enlarged surface. His interest centered on honeycomb and cellular designs based on natural forms and he developed a great many complex and varied kite designs. It is interesting that many of the early airplanes very much resembled variations of the box kite (Figure 44). In most cases, especially in Europe, it was only gradually that the side panels were removed from the wing structures, to which ailerons were first added, and the vertical stabilizing function taken over by the tail fin.

We tend to forget now that the word "plane" in airplane refers to the wings and that the now old-fashioned terms "bi-plane" and "tri-plane" referred to the number of wing layers, or planes, and not to the number of engines.

Hargrave made a further contribution to flight design by developing the use of cambered aerofoils — curved panels — which tend to reduce rearward air turbulence and to increase lift.

Stability and high lift were among the early requirements of airplane designs because of the weight and low efficiency of the early engines, and for this reason kite designs were very influential. The development of stronger engines completely changed these early requirements and permitted the development of modern single-wing planes. However, the genius of the Wright Brothers lay in part in their recognition that, with power, stability was not as vital as maneuverability, and that lift assumed a somewhat different character when no longer dependent on wind power alone. Their experiments centered on adjustable aerofoil panels and warped wing surfaces. In doing so they left kites behind.

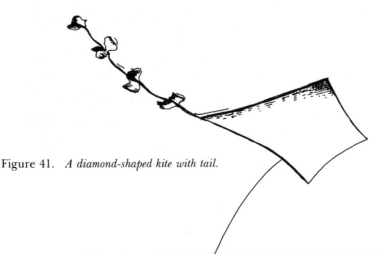

Figure 41. *A diamond-shaped kite with tail.*

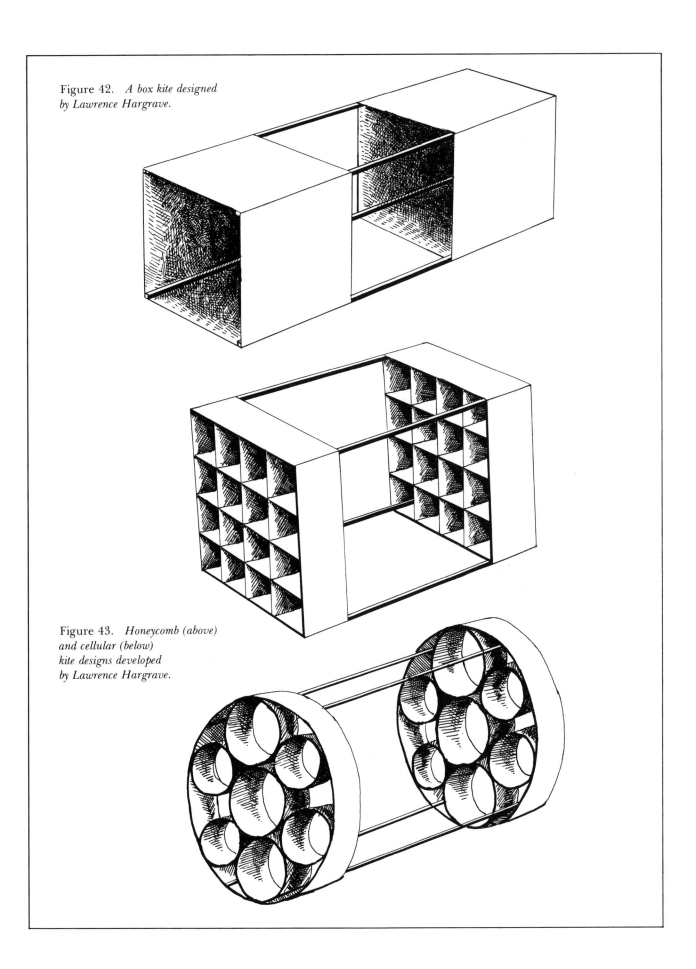

Figure 42. *A box kite designed by Lawrence Hargrave.*

Figure 43. *Honeycomb (above) and cellular (below) kite designs developed by Lawrence Hargrave.*

Membrane Structure, *metal and paper. This complex beetle-like construction consists mostly of curved triangular shapes. It has an open base and a superstructure that is partially enclosed in wax paper.*

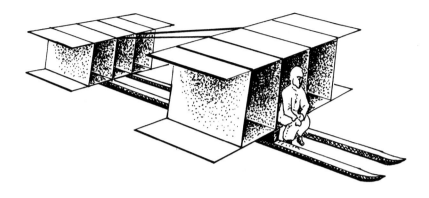

Figure 44. *The Archdeacon, a floating glider, designed in 1905.*

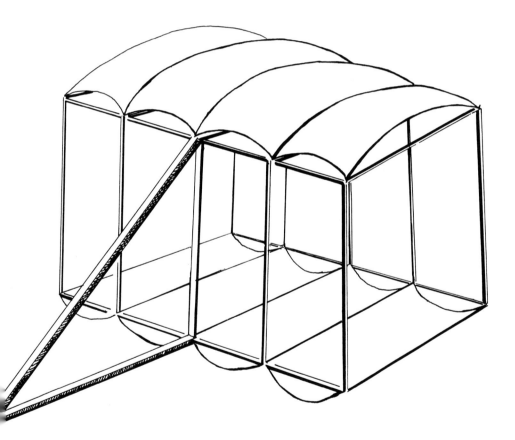

Figure 45. *The Wright Brothers'* Glider No. 1, *which was flown as a kite.*

17　Growth and Change

"By this tenuous thread of living protoplasm, stretching backward into time, we are linked forever to lost beaches whose sands have long since hardened into stone."
Loren Eisely

From the mysterious moment when the first cells divided, from the first effort of living forms to reproduce themselves, life has meant birth, multiplicity, growth, movement, interaction, change, and death. The overriding principle of life has been continuity.

Creation implies transiency. Form requires formlessness. Multiplication, adaptation, and growth impose a time limit on all living structures. Leaves, eggs, animals, and seeds, like all of nature's creations, are only temporary forms that insure the continuity of life. They exist in such great quantity that we think of them as permanent and guaranteed. But their permanence is of the most delicate kind. Each form of life is required to make the difficult effort of self-renewal. It is through this process that forms change, in infinitesimal steps, to meet new needs. Every natural structure has been created by change, by adaptation, by minute variation, by a million rebirths. Living forms may change, may remain, and may disappear through the process that created them.

Life produces quantity which insures diversity. Nature, like most artists, cannot repeat itself exactly. The age of the machine has demonstrated man's yearning for precision and exactitude, yet men cannot produce exact copies without machines. From variation comes art, and from this simple inability for precise replication comes the variety of all life's forms.

Every attempt to achieve exact simulation kills life. The essence of life is variety, which in turn is the basis for continuity. Things that never change are rightly considered inhuman. It is curious that the ability to make exact copies demands a disinterest in the purposes of the original, while the characteristic of all man-made things is inexactitude. No hammer blow, no handclasp, no jump can be exactly duplicated. No bones, eyes, teeth, or thumbs are ever exactly alike.

Since pairing is a common attribute of living forms — two arms, two legs, two eyes, two sexes — odd numbers tend to assume a particular importance in nature. In the multiple births of animals, the number five guarantees the supernumerary, the extra who must seek fulfillment outside the family circle. Number five is the force of change, the disturber of the status quo, the intruder on the settled relationship. He makes the arrangements with the other side. He is the loose number, the available atom of oxygen ready to form a new chemical combination. Five is the disharmony which demands change. Five is a symbol of nature's bias for variety and growth. Five, we know, is related to the flower of the fruit tree, to seeds, to the pentagon, and to the spiral which has no end.

148

Birth and Beginnings, *pencil on paper. A sensitive drawing combines ideas of fertilized eggs, growing embryos, births, and beginnings.*

The growth of plants and animals, of fungi and algae, of insects and invertebrates, is subject to different laws and different processes. But all growth is marked by phases in which changes occur by addition, by loss, by reduction, by extension, by enlargement, or by elongation. Growth never takes place in a simple, linear progression. All complex organisms grow after birth, develop the means to interact and to reproduce, reach maturation, extend to maximum potential, and die. No orderly pattern describes these processes. Each is individual and varies with the species. Growth is change. Forms develop until they can fulfill their self-renewing functions and decline. Every stage is a form of maturation, made to appear permanent by quantity and by repetition.

The Problem To make a series of drawings which represent growth and change. No limit is set to the number required. You should make as many drawings as you think necessary to express the concept of growth, and you can use any medium. The drawings must show a process of change which is sequential, in which each stage grows or appears to grow naturally from the previous one.

The Drawings This problem is concerned with the visual presentation of an abstract idea — growth and change — a process to which all the forms of life are subject. We have dealt, in our problem on self-reproduction, with a series of drawings which are used to describe a cycle. This problem is related to it, but more difficult. Here the beginning does not anticipate the end, and there is no frame within which to work. In this problem you are free to make many drawings, to elaborate any variations of form you wish, to transform and metamorphose at will, to choose any beginning and to bring it to any end. You do need to provide a logical sense of continuity and some evidence that growth is more than simple change. As we have discussed, change is not simply a process of enlargement. The interrelationship of parts and the relative proportion of elements must all be considered in the process of growth.

In making a series of drawings which are related, it is important to select those moments which represent equally significant periods of change and which mark the crucial stages of growth. Your sequence should set off the necessary limits of time to indicate a measured progression.

Whatever your subject, you should choose forms which are familiar and easy for you to draw since they must be repeated with the appropriate changes and

Variations on the Form of a Bone, *ink and watercolor. This long scroll relates the shapes of bones to make a continual series of variations on shape and color.*

developments. Like a cartoon strip, the sequence must be read as a progression in which familiar elements are recognized from one frame to the next.

Hopefully, our study of nature will have provided you with many examples of form and ideas of structure which you can use in solving this last problem. It will be a test of your understanding of the many subtle processes which are related to growth and change. You may wish to use natural forms, abstracted forms, or geometric forms as the basis of these drawings. There are no stylistic requirements. The only realism sought is in the manner in which you can give the idea of growth and change a convincing visual form.

From the caves of Altamira and the wall paintings of ancient Egypt to the works of Rembrandt and Picasso, artists have made drawings in series that show change. Many have attempted to express this idea in a single composition through the symbolic arrangement of formal elements. It can be done. What you are being asked to do here is a difficult assignment since you are not provided with any subject and since you are dealing with an idea derived directly from nature. It is in the best artistic tradition and is a major test of your drawing skills.

Film studies showing the growth of plants and the opening of flowers, the development of a painting, or the building of a structure can convey the process of growth and change with an immediacy and drama difficult for the artist to match with a pencil. Films arrange sequences and condense time, and the pencil, in our age, may seem a slow and antiquated tool. Yet it can probe where the camera has not yet learned to see and it can clarify, for both the viewer and the artist, visual mysteries for which the moving picture has no patience. It can also guide and animate the imagination of the film.

Your drawings may be the scenario for an animated sequence whose ultimate realization will be on film. If it were possible, I would suggest that your next project be a film in which, by animation or some other means, you would express the idea of growth and change. Films may well be the ideal medium for expressing the adaptive, multi-purposed interrelated functions of natural forms. Continuity, growth, and change created these forms, and time is crucial to this process.

Whether armed with a pencil or a camera, it will always take the patience of an artist to notice the subtleties that distinguish the forms of nature, to unravel the sequences which constitute her history, and to measure the labored steps that created the natural, varied, wondrous, threatened, self-renewing world which is our home.

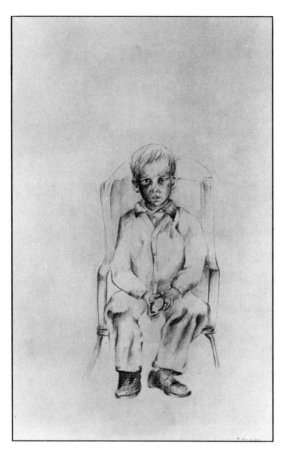

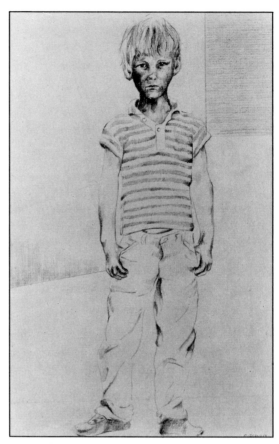

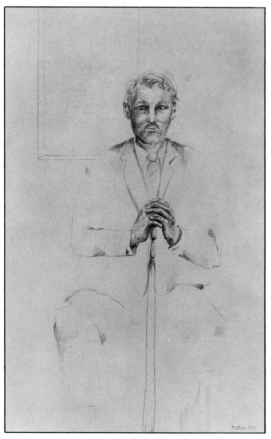

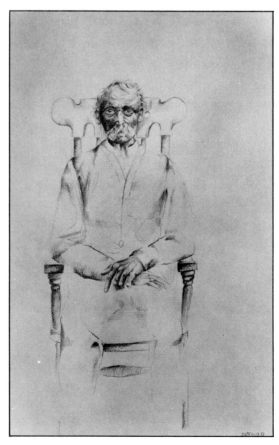

Childhood and Death, *pencil on paper. Drawings of figures representing different stages of life are used to express change and growth — from childhood to old age to death.*

Growth of a Form, *pencil on paper. A series of drawings using suggestive abstract forms to represent growth, proliferation, and enlargement.*

Bibliography

Ardrey, Robert. *African Genesis.* New York: Dell Publishing Company, Inc., 1963. London: Collins and Fontana, 1961 and 1969.

Bodor, John J. *Rubbings and Textures, A Graphic Technique.* New York and London: Van Nostrand Reinhold Company, 1968.

Bonner, John Tyler. *Morphogenesis: An Essay on Development.* New York: Atheneum Publishers, 1963.

Brassaï. *Picasso and Company.* New York: Doubleday and Company, Inc., 1964.

Clark, Kenneth. *Leonardo da Vinci.* Cambridge, England: Penguin Books, Cambridge University Press, 1958.

Collier, Graham. *Form, Space and Vision.* Englewood Cliffs, New Jersey: Prentice-Hall, Inc., 1967.

Corner, E. J. H. *The Life of Plants.* New York: The American Library, Inc., 1968.

Critchlow, Keith. *Order in Space.* New York: Viking Press, 1970. London: Thames and Hudson, 1969.

Crockett, James Underwood, and Editors of Time-Life Books. *Annuals.* Time-Life Books, 1971.

Crockett, James Underwood, *The Trees.* New York: Time-Life Books, 1972.

D'Arbeloff, Natalie. *Designing with Natural Forms.* New York: Watson-Guptill Publications, 1973.

Darwin, Charles. *The Origin of Species.* Baltimore, Maryland and London: Penguin Books, 1968.

Eiseley, Loren. *The Immense Journey.* New York: Vintage Books, Random House, 1957.

Eiseley, Loren. *Darwin's Century.* Garden City, New York: Doubleday and Company, Inc., 1961.

Eiseley, Loren. *The Firmament of Time.* New York: Atheneum Publishers, 1966.

Elsen, Albert. *Rodin.* New York: Museum of Modern Art, 1963.

Fuller, Buckminster. *Ideas and Integrities.* New York: Collier Books, The McMillan Company, 1969.

Gardner, Martin. *Mathematical Puzzles and Diversions.* New York: Simon and Schuster, 1961. London: Bell, 1961.

Hale, Nathan Cabot. *Abstraction in Art and Nature.* New York: Watson-Guptill Publications, 1972.

Hale, Robert Beverley. *Drawing Lessons from the Great Masters.* New York: Watson-Guptill Publications, 1965.

Herbert, Robert L., Ed. *Modern Artists on Art: Ten Unabridged Essays.* Englewood Place, New Jersey: Prentice-Hall, Inc., 1964.

Hertel, Heinrich. *Structure, Form and Movement.* New York: Van Nostrand Reinhold Company, 1966.

Hiyama, Yoshio. *Gyotaku.* Seattle, Washington: University of Washington Press, 1965.

Huxley, Aldous. *The Doors of Perception; Heaven and Hell.* New York: Harper and Row, 1963. London: Chatto, 1968.

Kepes, Gyorgy, Ed. *Education of Vision.* New York: George Braziller Inc., 1965.

Kepes, Gyorgy, Ed. *Structure in Art and in Science.* New York: George Braziller, Inc., 1965.

Kepes, Gyorgy, Ed. *Sign, Image and Symbol.* New York: George Braziller, Inc., 1966.

Kubler, George. *The Shape of Time.* New Haven, Connecticut: Yale University Press, 1962.

Lanham, Url. *The Insects.* New York: Columbia University Press, 1964.

Lanyon, Wesley E. *Biology of Birds.* Garden City, New York: The Natural History Press, 1964.

Lorenz, Konrad. *On Aggression.* New York: Harcourt Brace and Jovanovich, Inc., 1967. London: Methuen, 1966.

McWhirter, Norris and Ross McWhirter. *Guiness Book of World Records.* New York: Sterling Publishing Company, Inc., 1972.

Maholy-Nagy, Lazlo. *Vision in Motion.* Chicago: Paul Theobald, Co., 1969.

Moholy-Nagy, Sybil. *Matrix of Man;* An Illustrated History of Urban Environment. New York: Praeger, 1968.

Mongan, Agnes. *Andrew Wyeth;* dry brush and pencil drawings. Greenwich, Conn.: New York Graphic Society Ltd., 1966.

Moorehead, Alan. *Darwin and the Beagle.* New York: Harper and Row, 1969.

Nicolaides, Kimon. *The Natural Way to Draw.* Boston: Houghton Mifflin Company, 1941.

Ommanney, F. D., and Editors of Life. *The Fishes.* New York: Time, Inc., 1964.

Ore, Oystein. *Graphs and Their Uses.* New York: Random House, 1963.

Portmann, Adolf. *Animal Camouflage.* Ann Arbor, Michigan: University of Michigan Press, 1959.

Randall, Reino, and Edward Haines. *Design in Three Dimensions.* Worcester, Massachusetts: Davis Publications, Inc., 1965.

Ray, Carleton, and Elgin Ciampi. *The Underwater Guide To Marine Life.* New York: A. S. Barnes and Company, 1956. London: Kaye and Ward, 1958.

Roland, Conrad. *Frei Otto: Tension Structures.* New York: Praeger, 1970.

Salvadori, Mario, and Robert Heller. *Structure in Architecture.* New Jersey and London: Prentice-Hall, 1963.

Soby, James Thrall. *Arp.* New York: Museum of Modern Art, 1958.

Soby, James Thrall. *René Magritte.* New York: Museum of Modern Art, 1965.

The Structurist Magazine, No. 8., New York: Wittenborn and Company, 1968.

Thompson, D'Arcy Wentworth. *On Growth and Form.* Cambridge, England: Cambridge University Press, 1961.

Vaczek, Louis. *The Enjoyment of Chemistry.* New York: Viking Press, 1965. London: Allen and Unwin, 1965.

Walter Murch: A Retrospective Exhibition. Providence, Rhode Island: Museum of Art, Rhode Island School of Design, 1966.

White, Lancelot Law, Ed. *Aspects of Form.* Bloomington, Indiana: Indiana University Press, 1966. London: Lund Humphries, 1968.

Wilson, Carl L., and Walter E. Loomis. *Botany.* New York: Holt, Rinehart and Winston, 1967.

Winkler, Joseph R. *A Book of Beetles.* London: Spring Books, 1964.

Index

Edited by Jennifer Place
Designed by Robert Fillie
Set in 10 point Baskerville by Computex Corp.
Printed and bound by Halliday Lithograph Corp., Inc.